Andrew M Butler & Bob Ford

The Pocket Essential

POSTMODERNISM

www.pocketessentials.com

First published in Great Britain 2003 by
Pocket Essentials, P O Box 394, Harpenden, Herts, AL5 1XJ, UK

Distributed in the USA by Trafalgar Square Publishing,
PO Box 257, Howe Hill Road, North Pomfret, Vermont 05053

A CIP catalogue record for this book is available from the British Library.

ISBN 1-904048-24-2

2 4 6 8 10 9 7 5 3 1

Book typeset by Wordsmith Solutions Ltd
Printed and bound by Cox & Wyman

To Rahila Khan and Ern Malley, for being themselves.
Who else could they be?

Acknowledgements

This book would not have been possible without a modem which enabled many gigabytes of files to fly back and forth between High Wycombe and York. We'd also like to thank our service providers for not crashing when it was inconvenient. We'd like to, but...

We've both benefited over the last decade and more from conversations for and against postmodernism with many people. For these and much more we'd like to thank: Cathy Cundy, Roger Luckhurst, Mike Sanders, James Nicholls, Istvan Csicsery-Ronay Jr, Veronica Hollinger, John Mercer, the late JDR, Robert Edgar, Joan Gordon, Rob Latham, Xavier Mendik, Greg Tuck, Damien Broderick, Simone Armstrong, the staff of the White Eagle, Stoneygate, China Miéville, James Kneale, Charlie Blake, Françoise Cambridge, Colin Aintree, Andrew and Andy Macrae, Nigel Harwood, Jan Copeland, Mark Bould and Paul Kincaid, and all whose bookshelves and video collections we raided.

A nod from AMB to the Prefabs, re-enactors of *Crash* and from BF to K—, for rushing to paradise and back.

CONTENTS

Introduction

Postmodernism is a movement, a set of aesthetics, a cultural logic, an ideology, a Zeitgeist, an age, an ethos, a mood. It's a bandwagon. It's a scam, a con trick, an example of the emperor's new clothes, nihilistic nonsense, dangerously fascist and right wing. It's the only surviving form of Marxism. It's a continuation of modernism. It's a rejection of modernism. It is what you need *before* you can have modernism. It is nothing to do with modernism. It is the only way to understand *now*. It's all over now. It never existed. It's...

Postmodernism is difficult to explain and certainly difficult to define, if only because a whole series of different people have used words like 'postmodern', 'postmodernism' and 'postmodernity' and meant vastly different things by them. Almost the only common element is that postmodernism is typified by the difficulty of defining *anything* at all. This would suggest that it is impossible to define. But hey, we love a challenge.

We're going to lay out the basic groundwork for understanding postmodernism, and the intellectual and artistic background to it, although this can only be a series of gestures in the right directions. In the next four chapters we will explore the ideas of a series of thinkers such as Jean-François Lyotard, Fredric Jameson, Jean Baudrillard, Donna Haraway and Julia Kristeva, who we feel are key postmodern thinkers. In chapter five we focus on science fiction, a genre which seems particularly open to postmodernist interpretations. Then chapter six explores a number of novels, films, television programmes and so forth which could be considered as postmodern. We hope that the texts we have chosen form a net in which something of the postmodern can be caught. The final chapter offers some of the common criticisms of postmodernism.

We insist on 'we', because this book is very much a joint effort. One of us is madly keen and enthused by the whole idea of postmodernism and the other is deeply sceptical; we're just not sure which one of us is which most days. Bob has drafted bits which were then rewritten by Andrew and vice versa, and both have found ourselves (themselves?) disagreeing with things that they themselves had written in the first place. (He's not wrong there. Or did I write this bit?) We've tried to preserve a few moments of disagreement and contradiction.

So where to start? Most critics have assumed that postmodernism (and postmodernity) comes after modernism (and modernity). The terms might

more clearly be labelled postmodernism and postmodernity. First it would be helpful to see what they are post to.

Modernism(s) And Modernity

Art and cultural historians have attempted to make sense of the history of aesthetics by dividing it up into different movements and periods. From the time of Giotto in the early fourteenth century through to the seventeenth century is the Renaissance, characterised by the rediscovery of techniques from earlier periods, as well as a greater sense of life-like realism within artwork which started to use lines of perspective; it also marked a return to Classical Greek (Sixth-Third Centuries BCE) and Roman (Fourth Century BCE-Fifth Century AD) values, paying attention to geometric form and human values.

Another such period is the modernist era, which begins in the second half of the nineteenth century and ends during the 1930s. The nineteenth century had been one of immense optimism, marked by the growth of British and French empires and by advances in technology, such as the telegraph and the train, which bridged distances. In 1851 an exhibition was housed in a vast glasshouse in Hyde Park, London, to show off the treasures of empire and the achievement of Victorian man (or, less often, woman). The exhibition proved such a great success that the money from it was used to buy land for the various museums and Imperial College in South Kensington and to build the Royal Albert Hall.

Curiously it was the very success of human endeavour that led to the collapse of that optimism: Charles Darwin (1809-1882) had revealed that humanity was descended from an ape, Sigmund Freud (1856-1939) was to suggest that there was more to identity than the conscious mind, and astronomy was proving that Earth was an insignificant speck in an infinite universe. There was an increasing sense of a void at the heart of society. Throughout the nineteenth century, people were drawn to the great cities of Europe and the United States, and people began to mix more than ever before with those of different racial, ethnic, religious, political, social and sexual backgrounds. You could find yourself in a crowd of thousands of people and yet still feel isolated. The sense of doom which ran all the way through the *fin-de-siècle* of the nineteenth century into various political crises in the first decade of the twentieth century exploded with the assassination of Archduke Ferdinand of Austro-Hungary in 1914. This event led Germany to declare war on Russia but to invade France, their route through Belgium causing Britain to declare war on Germany. Hundreds of thousands were killed on the battle fields, and

then millions were killed in an influenza epidemic in the winter of 1918. In Russia there had been two revolutions in 1917, and now a former imperial ally was a new Soviet state; further revolutions were feared across Europe.

There was an explosion in the arts, marking attempts to depict this new sense of the world – crystallised for many in the Post-Impressionism exhibition in London in 1910. Not only were there a whole series of movements of painters (Cubists, Vorticists, Futurists...) but there was also a sense of the avant garde in theatre, in ballet (Stravinsky's *Rite Of Spring* (1913)), in poetry (the early works of TS Eliot (1888-1965) such as *The Waste Land* (1922)) and in the novel (James Joyce (1881-1941), especially *Ulysses* (1922)). Such artworks attempted to be new, to represent the world in new ways, to reflect the sordid, sexual side of reality as well as its beauty, and would often be fragmented in form, alluding to earlier works of art. In painting it was realised that a picture does not have to be a depiction of an exterior world: you can paint an entirely blank canvas or give people more than one nose. In sculpture Marcel Duchamp (1887-1968) played with the very notion of art by sticking a urinal in a gallery and signing it.

By the 1930s the modernist movement began to subside; the artists had moved on to other things or had died, and the ability to shock had been diluted. As many of the avants-gardists aged, they shifted to the right, whereas the art of the 1930s began to be dominated by socialism and communism, centring on the war in Spain between the communists and the nationalists. Art became much more politically committed. Postmodernism can be seen as a resurgence of this lost avant garde, after the Second World War, with Andy Warhol (1928-1987) and then Pop Art being key early examples. Having been a commercial artist, Warhol began painting labels from Campbell's Soup Tins or Brillo Pad boxes, producing works of art where the originals had been advertising. Silkscreen prints of Elvis, Marilyn Monroe, Marlon Brando and so forth offered an aesthetics of the allure of celebrity and fame, as Warhol himself became a celebrity. Pop Art also looked to commercial images – using the imagery and subject matter of comic strips, flat colours from a limited palette and techniques of collage and photography.

So much for moder*nism*. On the other hand, perhaps we're really interested in the *idea* of moder*nity*. Again we need to think about history as being broken down into periods: the Classical Age from the rise of Greece to the fall of Rome, the Middle Ages (which wane until the seventeenth century), the Renaissance or Early Modern period (which begins sometime in the fourteenth century, give or take a century) and then the modern period. Of course

every society, more or less, has thought itself modern; the word, which means 'Right now', was coined in the fourth century.

Through the eighteenth century, though, there emerged a whole series of thinkers who wished to use logic and science to understand the world and to put humanity firmly in charge: writers, scientists and satirists such as François Voltaire (1694-1778), Denis Diderot (1713-1784), Gotthold Lessing (1729-1781) and Immanuel Kant (1724-1804) argued that the universe has a material rather than a spiritual origin, and can be understood by the application of intellect. The intellect can set the individual free, an individual who is a citizen of the world and has certain rights (and responsibilities).

This period is known as the Enlightenment and its concepts helped pave the way for the written constitutions for the new republics of the United States (1776) and France (1789), in the case of the former ensuring the separation of state from any religion. The individual had the right to be educated and the right to vote – even, eventually, the right for women to vote – in a democratic state. The industrial revolution, which also began in the eighteenth century, saw humanity harnessing the elements, and the rise of mass production and, in time, mass reproduction, mass media and mass communication.

This Enlightenment idea of modernity came into disrepute, as rationality could not rescue humanity from terror – whether the terror following the 1789 French Revolution or the death camps of Hitler and Stalin. Modernity was either a spent project, or still needed to be pursued and corrected. Despite the materialist basis of Enlightenment thought, there is still a sense of the transcendental in the transformation of humanity through rational thought and education.

Plato and Heraclitus

But perhaps we are beginning this account too late in history. The ideas of Plato (c.427-347 BCE) are central to Western philosophy, and were usually written in the form of dialogues between Socrates (c.470-399 BCE) and one or more pupils, with Socrates questioning the ideas of his charges and trying to trap them into contradicting themselves. His influence upon later Greek philosophers, as well as Christian thinking and later philosophy, is incalculable. Philosophy is largely a series of footnotes to Plato, sometimes questioning and disagreeing with, but never entirely rejecting him. Taken together these ideas are known as the Western metaphysical tradition. There is space

here just to pick out two of his ideas: the story of the early days of writing from *Phaedrus* and the Allegory Of The Cave from *The Republic*.

Theuth, the god who invented numbers, calculations, geometry, astronomy and writing, tries to justify his inventions to Thamus, king of Egypt, who then determines whether they are good or bad. Through Thamus and Socrates' reactions, we have to conclude that writing is bad, because it is fixed and rigid and therefore cannot be questioned or debated. Speech, on the other hand, can shift to fit the individual situation; the speaker can explain things further which have not been initially understood, or fill in details which were omitted. To this day, court cases rely upon oral testimony, in which the truth of the speaker's words is guaranteed by their presence in the room; in the case of writing (say, a signature on a cheque) the writer is usually absent when the words are read, and what they have written has to be taken on trust. Writing is a form of lies. In the two millennia since, speech has come to be more important than writing.

In the Allegory Of The Cave a group of people have been chained in a cave since their birth, and watch the progress of shadows cast on the wall in front of them. If a prisoner were to escape or be released, she would discover that the shadows are cast by objects moving between candles and the cave wall, and there was a whole world outside the cave. However, the prisoners would be unlikely to believe her and would think her mad. The purpose of the Allegory is to demonstrate the notion of enlightenment, and the path of the individual towards the truth. But later in *The Republic* Socrates discusses a craftsman making a bed and a table, which are based upon what his idea of a bed and a table are. It is these ideas (or ideals, depending on your translation) that is true reality and our everyday world is an imitation of that world of idea(l)s. To take it a stage further, realist art – here meaning art that imitates the world – is a copy of a copy, and is a dangerous lie.

In the earlier philosopher, Heraclitus (c.544-c.483 BCE), there is a similar sense that reality as perceived is not the truth: 'The nature of things is in the habit of concealing itself' (Fragment 123). Most people are ignorant, deluding themselves as to what reality is, thinking they know the truth: 'Most men do *not* have thoughts corresponding to what they encounter; they do not know what they are taught, but imagine that they do' (Fragment 17). In fact, reality is in a constant state of change or flux: 'Upon those who step into the same rivers, there flow different waters, in different cases' (Fragment 12).

Heraclitus is one of a number of philosophers who are known as the pre-Socratics, not necessarily because they are earlier than Socrates (although

many are) but because their ideas are at odds with Socrates. Their number include Pythagoras (c.582-500 BCE), Diogenes (c.412-323 BCE), Zeno (c.490-430 BCE) and Parmenides (c.510-450 BCE), and they sought universal rules to explain reality and humanity. Most of their works survive only as fragments, in quotations in other writers, such as Plato. Of course this is also true of Socrates', and we can take the ideas of Socrates in the dialogues to be Plato's. Since many of the pre-Socratic ideas predate Plato's, or are different from Plato's, these ideas are at odds with the western metaphysical tradition. The first postmodern thinkers pre-date even the idea of the modern.

Modernity stands at the end of a long line of philosophical footnotes to Plato – who first imagined a rational state (no poets allowed) in his *The Republic*. From the 1920s onwards a series of philosophers began to try and break with what is known as western metaphysics, among them Martin Heidegger (1889-1976), Emmanuel Levinas (1906-1995), Michel Foucault (1926-1984) and Jacques Derrida (1930-). Between them these thinkers questioned the old binary that something was either here or not here (especially Derrida), the relation of the individual as a unified individual, the ethical relation of the observer to the rest of universe (Levinas, more problematically Heidegger) and the notion that there was something universal called human nature (Foucault). Jacques Derrida, in his essay 'Plato's Pharmacy', makes a case for writing over speech, in part depending on Plato/Socrates/Thamus's use of the word *pharmakon* to define writing, a word which has been taken to mean 'poison', but can also mean 'cure'. Elsewhere he writes of the nature of the signature, an event which guarantees the truth or validity of something while the guarantor is absent and yet present. Derrida, in his break with Plato, doesn't simply reverse Plato's ideas, but redefines the terms.

Architecture

It was in the realm of architecture that postmodernism (or post-modernism) came to the fore as a label. Modernism had been the dominant form of architecture through the twentieth century, initially in the kick-starting of European economies after the First World War. The idea was that the functional, flat surfaces would offer people the rationality of machines in a design which could be reproduced throughout the world; such modernism became known as the International Style. Architectural modernism was further boosted in post-Second World War rebuilding – which in turn led by the 1960s to wholesale destruction of historical buildings. Drawing on new methods and materials – glass, steel and concrete – modernism rejected ornamentation in favour of

function dictating form. Architects such as Le Corbusier (1887-1965) felt that architecture could change people, and a strain of utopianism can be traced through many of the projects for housing and communities.

Modernist buildings have experienced problems with cracks in glass, the inability to seal frames and roofs against wind and rain, degradation of materials in general and poor acoustics. Britain's experience of such architecture in the 1960s can show its shortcomings, especially in the South Bank complex of the National Theatre, National Film Theatre and the Queen Elizabeth Hall. The concrete has become discoloured over time by the impact of rain, mixed with pigeon excrement. The walkways in the sky may offer vistas of the river, but they also offer the chance to be windswept and create dark stairways which offer the chance to be mugged. Elsewhere in Britain such design replaced back-to-back slums with 'communities in the sky' in low rise developments of flats. In too many inner cities these provided the perfect locations for riots, where the walkways could be converted to battlements from which missiles could be hurled.

On 15 July 1972 a prize-winning housing complex, Pruitt-Igoe in St Louis, Missouri was demolished as uninhabitable – the complex was designed by Minoru Yamasaki who also designed the World Trade Center twin towers in New York. The former demolition may be seen as the death of architectural modernism.

In the mid-1960s architect Robert Venturi (1925-) had called for an architecture that would take the past into account, which would allow for symbolism within the form of the building to display its purpose. New buildings could quote earlier styles, say baroque. Similarly Charles Jencks (1939-) called for a postmodernist architecture which would return to the ideas of Classical good form and quote earlier styles in its appearance, without entirely rejecting modernity altogether. The right combination of styles offers a 'disharmonious harmony', while the redevelopment of city centres provides space for an 'urbane urbanity'.

Jencks describes postmodernism as involving: 'paradox, oxymoron, ambiguity, double-coding, disharmonious harmony, amplification, complexity and contradiction, irony, eclectic quotation, anamnesis [unforgetting], anastrophe [reversal of order], chiasmus [inversion of parallel structures], ellipsis, elision and erosion'.

An American example is Philip Johnson's AT&T building in New York (1978-1984). In form this returns to a pre-First World War technique of attaching granite to a steel framework, with a quotation from Classical form in

the shape of a cornice and base. The cornice, deliberately broken, appears Chippendale in style, whereas the base entrance is shaped as an archway. The whole is somewhere between a grandfather clock and a narrow wardrobe. Because the architectural forms appear already degraded or seem no longer complete, a sense of loss is present in this form of postmodernism. Jencks discusses James Stirling's extension to the Tate Gallery (now Tate Britain) (1982-1984) which connects it to the Clore Gallery. The whole is unified by a pattern of square grids, which brings a (discontinuous) unity to the whole. The wall surfaces which connect to the Tate include the stone and cornice work of the Classical original, and where they connect to a brick building it reproduces the red of the brick and the white of the cement. Elsewhere there are grids of green glass, in the entrance and reading room, and differing styles for the loading bay and sides.

It is difficult to see whether current architecture is predominantly Late Modern or Post-Modern: buildings by Richard Rogers, Norman Foster and others include large areas of glass, such as the Urbis building in Manchester, England, or the glass city hall in London with its internal spiral ramp which seems specifically *not* designed for wheelchair access. The Royal Festival Hall may be returned to its original layout, while the rest of complex faces piecemeal redevelopment rather than a complete rethink (the hall proving more successful than the more featureless Millennium Dome). The various stations on the Jubilee Line extension from Waterloo through to Stratford offer glass pyramids and concrete vaults, which so far don't feel oppressive.

Our World As Postmodern

Postmodernism in architectural form is perhaps the most visible of several kinds of postmodernism which permeate our world. The eclectic, camp and kitsch parodies of such buildings are echoed in television programmes, films and books, not to mention in music, clothes and virtually everything else. Everything seems to be double-coded, paradoxical, winking at us that it shouldn't be taken too seriously while of course it *is* too serious.

The alienation which was characteristic of the modernist metropolis is further visible in the utopian sprawl of suburbia and loft conversions; we may not know our neighbours anymore but we can have email conversations with friends we've never met in Los Angeles and Melbourne and prefer to text message a mate than have a conversation with the person sitting next to us on the train.

The horrific events of 11 September, for all their echoes of a disaster movie, have led to a new spirit in the world. The War on Terror, much more than the War on Drugs, is a fight against an abstraction, as a new, post-imperial bogeyman is established in the form of a religious and ethnic other. Innocent victims are contrasted with guilty (but rarely put on trial) perpetrators – as any sceptical statement about the injustices of World Trade is automatically taken to be a statement in favour of terrorism (just as the Cold War 'choice' was between democracy and communism). But nevertheless these events might form the twin to the JFK assassination: the end of the sense of the end, the end of postmodern relativism.

Mostly we will reserve the case against postmodernism for Chapter Seven. In the meantime, we need to look at this philosophy of endtimes and uncertainties, and the collapse of certainty described by Jean-François Lyotard (1925-1998) in his book, *The Postmodern Condition* (1979).

1. Jean-François Lyotard

The Postmodern Condition

Jean-François Lyotard's best known contribution to the consideration of the postmodern is his book *The Postmodern Condition: A Report On Knowledge* (1979) which was actually commissioned as a report by a university. Quite what the university did with the report doesn't seem to be recorded anywhere, but that's perhaps beside the point. Lyotard rather acutely describes the student population as being divided into three: those who are going into the professions who are given enough knowledge to do their jobs, a new technological élite who are being given new knowledge, and then a whole mass of people who are actually unemployed but don't appear in the official figures because they are registered as students.

It used to be that universities were warehouses of knowledge, and the hoarding of that knowledge for its own sake was a good thing; as the monasteries had guarded civilisation from extinction in the Middle Ages, so the university can do the same today. Rather than endless copying of scrolls and manuscripts, the lecturer offers knowledge to the student to copy down and then tests the accuracy of that transcription.

From the period of the Enlightenment onwards, with the growth in numbers of universities, there was an increasing sense that this knowledge was useful. On the one hand it would be possible to uncover the truth about the universe and to liberate humanity through that knowledge, on the other hand all the branches of knowledge that were developing could one day be brought together, and form some kind of total knowledge.

It might worth taking a closer look at this knowledge, or how we know it. Simply stating something is the case does not make it true. Lyotard gives the example of Copernicus, who stated that the planets go around the sun in a circle. Copernicus might know this, but knowing it does not make it true: he has to state it, and someone has to hear it, and agree with it. He has to be able to defend his claim, and dismiss any objection. If the hearer agrees, we are a step closer to establishing the truth. But what is claimed to be true has to match the external reality being referred to. For example, you have a Dalí painting which you know is genuine because it bears his signature – although simply because he has signed a painting does not prove he painted it, nor simply because it has a signature does it mean he has signed it. You need some kind of provenance – which is legitimated because it is assembled by an expert

who knows these things. This makes a very important point about the nature of meaning, which is better to defer to in the next chapter when we can consider it in relation to Fredric Jameson's ideas.

Lyotard isn't denying the reality of the universe, rather he is suggesting that science is a kind of specialist language, in which statements *about* the universe are taken to be true because they have been tested by a set of scientists. Which and whose truths are tested needs to be decided, and how far you need to go before the status is granted needs to be decided – and in a sense this is a political act.

In the case of a planet's orbit all you really need is sufficient time, a telescope and something to plot the orbit with. You can then start making predictions about where the planet will be in a week's time. But science has become less empirical. Lyotard suggests you imagine a dog, which becomes more aggressive as it becomes more angry; at a certain level of aggression it will attack. On the other hand, Rover can also be frightened, and once the fear reaches a critical threshold it will run (the opposite of aggression). It is certainly possible to measure whether a dog is aggressive or trying to escape, and if it were possible to measure quantitatively anger and fear, you could graph the dog's possible behaviours. Lack of both means a stable dog which does neither; an increase in both leads to a dog which may attack or retreat or oscillate between the two. This behaviour cannot be predicted.

In the cases of quantum theory (the behaviour of the individual parts of an atom) and fluid dynamics (the flow of any liquid or liquid-like behaviour from a dripping tap to the crowd leaving a Manchester City match) scientists are able to evolve a mathematical language which can describe the behaviour of the substances or entities involved, without being able to predict what they will do. From quite simple equations, complex or chaotic behaviour can emerge.

This is all perhaps a side track from the state of knowledge – which in our era no longer is simply important for its own sake. What has emerged is business's need for knowledge. In Marxist terms, use value has been replaced by exchange value. It's not that our knowledge of, say, Postmodernism, is useful for educating others, but that we can sell this knowledge to those good folk at Pocket Essentials, who can then make a tidy profit from this book. Far from knowledge setting you free, knowledge is part of the way in which you are ensnared within capitalism. Knowledge simply makes you a more efficient cog in the machine.

Each age has its own set of stories to explain why things are the way they are – whether it is Christianity in the Middle Ages, liberation and emancipation through knowledge for the French Enlightenment, total, unified knowledge for the German Enlightenment or scientific rationalism in the twentieth century. These stories are called Grand Narratives or Metanarratives, which determine what we take to be true. Lyotard argues that 'Simplifying to the extreme, I define *postmodern* as incredulity toward metanarratives' (xxiv). After the holocaust of the Second World War and totalitarian régimes in Germany, the Soviet Union and Italy we don't believe in emancipation through knowledge or rationality or a totality of knowledge; the concentration camps and gulags were the rational end result of industrialised war. We don't believe in Christianity, and some of the alternate ideologies which have emerged in recent centuries – capitalism and socialism – perhaps can't be believed in either.

One of the products of the Enlightenment was the nation state – obviously there were countries prior to the period, but now they had written constitutions or some kind of parliamentary elections, and increasingly the population had some say in their own governance. From the 1950s onwards, in the West, corporations have emerged which operate on a global scale beyond the confines of one nation. It is not trade between nations but across nations. Leisure wear manufacturers pay workers in the Far East or in Mexico pitiful wages to make their goods; they say if they paid any more, then other workers such as teachers would want to change jobs and start working in the factories. They hold western countries hostage with the threat of moving their business elsewhere. The days of the nation state are numbered, the days of modernity are numbered – and postmodernity lies in the wreckage.

(Hold up. Postmodernism is a way about talking about our current state of being, right? *Well, from the late fifties to the nineties, yes. I'm not sure about now.* So, postmodernism is a metanarrative, right? *Right.* But postmodernism doesn't believe in metanarratives. *Perhaps that means postmodernism doesn't believe in itself.* Isn't that a problem? *I guess so, but if I were you I'd move on. Anyway, Lyotard is talking about the postmodern, not postmodern*ism. What is postmodern*ism*? *Funny you should say that...*)

Answering the Question: What is Postmodernism?

Postmodernism can be described as a mix and match or pick and mix approach to life, where cultural boundaries are to be crossed and violated rather than respected: 'one listens to reggae, watches a western, eats McDonald's food for lunch and local cuisine for dinner, wears Paris perfume in Tokyo and "retro" clothes in Hong Kong; knowledge is a matter for TV games' (76). Each of these habits, of course, is part of consumerism, with the only boundary being what you can convince your bank you can afford. Within art, anything goes, as long as it sells.

In order to survive, capitalism needs to appear to be all things to all people, and appear to gratify every desire. The buzz or aura which owning a particular kind of footwear grants is to be relished, but of course it cannot be enough because you need to go on and buy the next thing, get the next buzz. Lyotard wrote 'Answering the Question: What is Postmodernism?' and discussed such issues in 1982, at the beginning of the decade of the yuppie.

Since writing *The Postmodern Condition*, Lyotard had been attacked by a theorist named Jürgen Habermas, who was part of a tradition of German Marxists. Habermas had called Lyotard a *neoconservative*, and Lyotard hit back in 'Answering the Question', most conveniently found as the Appendix to *The Postmodern Condition*. Habermas had stuck up for modernity, calling it an incomplete project that had yet to bear all its fruits. Twentieth-century life had splintered and fractured, leaving nothing but individual witnessings. The rôle of art is to bridge the gap between politics, ethics and knowledge, to bring us a unified, total experience.

For Lyotard, though, the total or totalised experience is just a step away from totalitarianism, and the ultimate end of modernity lay in Auschwitz. Attempts to impose a total, a whole culture have led to terror, and Lyotard sounds his own rallying cry: 'The answer is: Let us wage a war on totality; let us be witnesses to the unpresentable; let us activate the differences and save the honor of the name' (82). This is perhaps to get ahead of ourselves, for we need to understand the idea of the unpresentable. The avant-garde artists of the early twentieth century quite often contained within their works the sense that something was missing, that there was a void at the heart of society, and indeed art. But because many of them would still paint a painting, or create a novel in a recognisable language, the unpresentable here is part of a nostalgic yearning for a time when everyone, everything, was whole. The postmodern

work of art is one which reinvents language, reinvents representation, which rejects the guidance of good taste or good forms and which has the unpresentable, the missing, the absence, the loss, as part of the fabric of the way the work works.

Now this is the point where it gets really tricky. Pretty well every generation of artists rebels against the previous generation, but in the first thirty years of the twentieth century the process seemed to speed up: the Impressionists, Cézanne, Braque and Picasso, Duchamp, Buren. Art almost trips over itself as it shifts from the Impressionist attempt to represent reality through splashes of light and colour to questioning the very notion of art by exhibiting a urinal. Lyotard writes: 'A work can become modern only if it is first postmodern' (79). This seems to suggest that postmodern art is more primitive than modern art; it expresses anxieties about the world without having managed to evolve to a state where there is good form, solace, consolation and aesthetics which are shared. It is an as yet untamed savage.

(*I don't like to worry you, but I've found another translation of the essay: 'Answer to the Question: What is the Postmodern?' in a book called* The Postmodern Explained To Children. *I thought we'd moved onto Postmodernism rather than postmodernity.* It's not clear cut. *Obviously. It ends: 'The answer is: war on totality. Let us attest to the unpresentable, let us activate the différend and save the honour of the name' (25). What's a 'différend'?* It's something that goes back to the idea of discourse, that because of our ideology or our prejudices, we speak a particular kind of language. Sometimes when you have a conversation with someone else, even though you're both speaking English, you're talking different languages. *Like talking to my boss.* Precisely. Now someone like Habermas would say that you can compromise. To synthesise the two into one – or a totality. Lyotard mentions the idea of appeasement early on in the article and we know where that led – the Second World War. But when you get this *différend* you *can't* resolve it. There is no communication because you have no common ground. *That's definitely what's going on with my boss. This sounds a bit dialectical though. If Lyotard is a neoconservative, how come he's sounding Marxist?* He used to be a socialist – in the 1950s. He moved away from it after the political failures of the late 1960s. Both Lyotard and Habermas have got socialist elements to their thinking and end up calling the other right-wing. It's a *différend* in itself. *My head's beginning to spin. I'm getting vertigo.* We'd better move on.)

2. Fredric Jameson

The Cultural Logic of Late Capitalism

Fredric Jameson has been a significant figure in literary and cultural studies since the late 1960s, having written a number of books which have set the tone for critical endeavour. He has synthesised elements of structuralism – the analysis of the structures within culture and cultural productions – Jacques Lacan's psychoanalytic theory and, always, versions of Marxism.

To understand his postmodernism, first expounded in a 1984 essay 'Postmodernism, or, the Cultural Logic of Late Capitalism', we need to go back to Karl Marx's idea of the base and the superstructure. To put it crudely, each society has an economic base, foundation or infrastructure, a means of generating wealth. For example, thirteenth-century England was dependent on agriculture; nineteenth-century England on cotton mills. The economic base determines (and the meaning of the word 'determines' is never quite defined) the kind of society which then exists: the superstructure. This includes its form of government, its sociology, its media, arts, politics, religion, ideology, education and so forth. As the base changes over time, so does the superstructure.

We shouldn't be too mechanistic in thinking about this model: the change doesn't happen all at once, and just as some cultural practices linger (or are residual), so some arrive ahead of time (or are emergent). The Thatcherite politics of the 1980s which decimated the coal and steel industries demonstrate that the superstructure can be a factor that changes the base (it doesn't just evolve). Equally the Blairite policies of the 1990s showed the elements of the superstructure can have an impact on other elements, as ideological shifts were designed to appeal to tabloid newspapers rather than the unions.

Postmodernism is the culture which emerges during the period of late capitalism – perhaps from the late 1950s or early 1960s onwards – probably during the presidency of Eisenhower in the USA and certainly by the assassination of John F Kennedy, a period which Lyotard saw as marking the end of European reconstruction after the Second World War. This idea of 'late capitalism' emerges from the writings of Ernest Mandel (1923-1995), who divides capitalism into three periods: market, monopoly and postindustrial. To some extent these are defined by the means of production and what is produced: from the 1840s the mechanical production of steam-driven motors, from the 1890s the production of electric and internal combustion engines,

from the 1940s the production of nuclear or electronically driven machines; postindustrial capitalism arrives with the splitting of the atom but takes a decade or so to filter through into industry itself. Further, these periods can be associated with the consolidation of the nation-state and pioneering entrepreneurs, the consolidation of empire and international trade via state monopolies, and in the postmodern era, the collapse of empire, the waning of the nation state and the emergence of multinational or transnational corporations – again a concept also considered by Lyotard.

In his article 'Postmodernism, Or The Cultural Logic Of Late Capitalism', Jameson attempts to describe the cultural aesthetics of postmodernism, not so much to celebrate this new age, but rather to attempt to reorientate us within this new period of confusion. Jameson offers what he calls a 'cognitive mapping', which will prevent us from sailing over the abyss. He breaks postmodern aesthetics down into several broad and overlapping areas: depthlessness, simulation, the waning of affect, the death of the subject, pastiche, schizophrenic écriture, the sublime and nostalgia. He argues that postmodernism is a period, but a period that no longer believes in history.

The postindustrial society, it should be emphasised, is not a society after or without industry. Rather it is a society in which everything – work, travel, leisure, health, education, information – is industrialised. While industry as we've come to recognise it – steel, coal, fishing – since the industrial revolution may have declined, at the same time music, literature, art have become an industry. The postindustrial society is another stage of the industrial society; Jameson allows even that postmodernism may be just another stage of modernism. Meanwhile capitalism is dominated by corporations that seem to have more power than many nation states and cannot be pinned down to one country – that most American of industries Hollywood is now as likely to get its finances from Tokyo as New York, and Twentieth-Century Fox is part of an organisation owned by an Australian who owns that British institution, *The Times* (as well as *The Sun*).

Depthlessness

Objects are depicted for their own sake, for the pleasure of their depiction, rather than for any purpose of revealing the nature of society or their historical context. The stylistic excess of writers such as William Gibson in *Neuromancer* (1984; see also Chapter Five and Andrew M Butler's Pocket Essential *Cyberpunk* (2000)) or the *mise en scène* of the Wachowski brothers, the Coen brothers and David Lynch, in which design is its own reward, offer us a

glimpse of the postmodern aesthetic. In a film like *Bound* (1996) there is an overwhelming sense that the world within the frame has been constructed, and that the floor patterns, the pictures on the wall, the objects on the desk of the main flat, are there for a reason, without the reason being necessary for a comprehension of the plot or indeed the film. *Miller's Crossing* (1990) opens with a (dream?) image of a hat being blown through a forest – perhaps later revealed to be the titular Miller's Crossing – and this hat later emerges as belonging to Tom, who spends much of the film trying to keep hold of it. The hat assumes an importance to the viewer which the film never actually explains.

Simulation

Realist art offers a reproduction of some external reality, which in the process comments upon that original. In the Allegory Of The Cave, discussed in the introduction, Plato argued that reality itself was a copy, of some ideal form or object on another plane of existence. A realist painting, for Plato, would have been a copy of a copy. And now in the twentieth and twenty-first centuries works of art are mechanically reproduced in their thousands, to a point that the copy becomes more significant than the original. A work of art becomes a commodity, something to be bought and sold, which brings with it a set of values and benefits which are not necessarily part of the original object. Indeed, we have this strange phenomenon – which we will return to in the next chapter – of the copy without an original or the simulacrum. In a society with virtual reality, the simulation is beginning to take over; there is no longer the sense that things are real or fake, because *everything* is fake (or real). Reality is constructed in particular ways, and can be represented or simulated through the use of photography, painting, writing and so on.

The Waning Of Affect

Postmodern aesthetics distance us emotionally from cultural productions; we are so busy being amused or awed (see the section on the sublime, below), that we no longer care or demonstrate empathy in the same way. In the modern, there was a sense of anxiety about the world, that something was wrong; this anxiety has disappeared, perhaps through some kind of compassion fatigue, to be replaced by a continual, mild, euphoria.

As an example consider the schlemiel-like losers at the centre of each of the films of the Coen brothers. It seems impossible to feel compassion or worry at the idea of kidnapping a baby from a loving mother while we are marvelling at the camera work. If it is difficult to feel any concern for the male characters it is almost impossible to feel any for the females, unless played by Frances McDormand. It's not that the films are pure intellectual exercises – but it's difficult to see any heart to them.

The Death Of The Subject

From the Enlightenment onward the individual came to have meaning, as a unique point in time and space. But in the postmodern period, the individual I (to borrow a notion from grammar, the subject, as in the person who 'performs' the verb), is not so easy to pin down as an individual. In part this is because of the increasing complexity of the construction of our identity.

Towards the end of the nineteenth century, Sigmund Freud proposed that each of us has an unconscious part of our mind. This is the source of the desires which determine how we behave. Such notions of a divided subjectivity have led to notions of schizophrenia or other versions of insanity as being models of subjectivity. The world is so fast, so big, and so saturated with information that it is increasingly difficult to plot and define an individual within the world. In these postmodern times, a nervous breakdown becomes the sane reaction to a lunatic world – as Joseph Heller's *Catch-22* (1961) repeatedly demonstrates. Such breakdowns are examples of the death of the subject, of the individual as a whole individual.

Fredric Jameson argues that this death is the result of the bureaucratisation and acceleration of late capital's culture; more radical thinkers might argue that the subject, the individual, has never been a complete whole and only the bourgeois ideology surrounding the family tries to make us believe it had been. This division can be seen in other areas of postmodern thought; either there has been a Fall (in the 1950s?) or there never was a golden age.

Pastiche

Because there is no longer such a thing as the individual, so there cannot be an individual artist. There cannot be a truly original voice in art, or other cultural productions, because there is no one to have the voice. Jameson's touchstone throughout his article is Andy Warhol, who presented paintings of soup

can labels rather than original compositions. The artisan, the artist, the writer, and so on, ventriloquises the styles of others. The Coen brothers, say, return to the style of noir writers such as Hammett and Cain in their films in lieu of creating their own personal style.

(*Is this the same thing as parody?* Well, Jameson is careful to distinguish between pastiche and parody. Pastiche is 'parody ... without a vocation' (17). In parody there's the sense that you are trying to spoof someone, to show them as being ridiculous, as being overwritten, say, whereas pastiche is simply borrowing the style of another. *Even though that other is dead?* So to speak. *Why is that pastiche rather than parody?* Er... because that's what Jameson says. *I can see there's a difference, just not why the terms are that way round.* Can I get back to you on this?)

Schizophrenic Écriture

In post-war philosophy, écriture is more than just a French word for writing. Jacques Lacan (1901-1981) argued that after resolving the Oedipus complex, the male child enters into the Symbolic Order. In part this is language, but it is a male-structured, logical language which structures the world through related concepts. In contrast, the female can never really be part of this as she is apparently castrated. French feminists, rather than rejecting this as the nonsense it so clearly is (*steady*), argued that what women really needed was a much more allusive or elusive, even an illusive (*steady*) language or *féminine écriture*. Such examples of *féminine écriture* as we have appear very modernist in form – see almost any sentence from Joyce's *Ulysses*. (*But Joyce wasn't a woman.* No, but his writing was feminine rather than masculine. See Chapter Four, when we write it.)

Schizophrenic écriture is the postmodern equivalent: fragmented, alluding to other cultural productions and making no distinction between reference to high art or low culture. *O Brother, Where Art Thou?* (2000) takes its title from a film within a film directed by Preston Sturges, and, like *Ulysses*, is a retelling of *The Odyssey*, incorporating elements of the musical, the chain gang movie, and Laurel and Hardy routines, and so on. The postmodern work of art brings together such references – you might say such codes. True meaning lies elsewhere (see Chapter Three) as we are struck simultaneously by these signs of culture.

The Sublime

The sublime is an idea most often associated with the Romantic period (say 1780-1830), coming from Enlightenment thinking. The individual could reach a state of transcendence through exposure to certain events or sights: views from the mountain tops, thunderstorms, deep valleys, sunrise on Westminster Bridge... The postmodern (or hysterical) sublime comes in part from the matrix of information that we are caught in, as we try to locate ourselves on the information superhighway. Jameson reminds us of the image of David Bowie, in *The Man Who Fell To Earth* (1976), staring at dozens of TV screens. Alternatively, think of the increased cutting speed and thus the rate of information offered us in the average pop promo. The romantic sublime transformed terror into pleasure; here we are stuck in perpetual euphoria – and we perhaps fail to see the terror underlying it.

Nostalgia

Of course, there was once a happier time, before it all changed. Except that history has collapsed and any attempt to look at a historical period is really an attempt to find out about now. Jameson identifies the genre of the nostalgia film, beginning with *American Graffiti* (1973) which recreates the 1950s and 'the henceforth mesmerising lost reality of the Eisenhower era' (19). The fact that the film is set in 1962 should not detain us as it does not detain Jameson; in a later chapter he considers *Blue Velvet* (1986) as another attempt to perceive the sordid underbelly of an idyllic 1950s and we might want to think of the *Back to the Future* trilogy or *Twin Peaks* as other explorations of a simulated 1950s.

This nostalgia reaches its zenith in the novel *Time Out Of Joint* (1959) by Philip K Dick (1928-1982), in which the reader is led to believe that the present is the 1950s. Ragle Gumm is the reigning champion of the 'Find the Little Green Man' competition, and keeps witnessing objects disappearing only to be replaced by slips of paper with the name of the object written on it. He finds a magazine featuring Marilyn Monroe, whom they haven't heard of, and Ragle overhears people talking about him on the radio. It turns out that it is in fact April 1998, and that Ragle has been plotting missiles fired in Luna's war with Earth; he'd retreated into a childhood fantasy of a more comfortable age, and the Earth powers had built a fake town to accommodate him in Wyoming. Of course to a reader in the 1990s or later, those scenes of the fake 1950s feel more realistic than the depictions of the 1990s. Fredric Jameson

writes that 'Dick used science fiction to see his present as (past) history' (296); the nostalgia film ends up reflecting its present by finding it back in the past. Nostalgia isn't what it used to be.

3. Jean Baudrillard

Jean Baudrillard (1929-) is a French philosopher who is perhaps the most controversial figure in postmodernism – and perhaps edges out Jacques Derrida as the most controversial figure in postmodernity. Like most of the French intellectuals of his generation – Derrida, Lyotard, Roland Barthes (1915-1980), Louis Althusser (1918-1990) and many others – he came through a Marxist apprenticeship and, like many of them, eventually broke with the ideas of Karl Marx. For many, the break point came after the Paris uprisings in May 1968 and the disillusionment which later set in amongst the left. For Baudrillard, the idea of ideology was not enough to explain the way capitalism sustained a willing market for its products; something more sinister was at work.

Hyperreality

Fredric Jameson's account of postmodernism includes notions of schizophrenic écriture, hysteria and the simulacrum, ideas which had already been developed by Jean Baudrillard over a number of years, often in relation to American culture and sometimes in relation to science fiction by Philip K Dick or JG Ballard (1930-). Like Jameson, Baudrillard foresees the death of the subject in the process of accelerated culture and aesthetics. He writes: 'today we have entered into a new form of schizophrenia – with the emergence of an immanent promiscuity and the perpetual interconnection of all information and communication networks. No more hysteria, or projective paranoia as such, but a state of terror [. . .] an over-proximity of all things, a foul promiscuity of all things which beleaguer and penetrate him, and no halo, no aura, not even the aura of his own body protects him [. . . the individual is] open to everything' (26-7). Jameson had of course wanted to find some kind of cognitive map which would help us find our way through the postmodern funhouse, but Baudrillard seems to celebrate it, while finding it terrifying.

This new kind of information dense culture is part of what Baudrillard calls hyperreality. We are in an age where our perceptions of the everyday world overlap with and are shaped by models of the world. There is a growing sense of inauthenticity about the world that surrounds us because it is increasingly constructed rather than natural. And the artificial is actually quite seductive – it is preferable to real life. The Italian author and academic Umberto Eco writes in his book *Travels In Hyperreality* about a visit to a theme park in the

southern USA; on a boat trip 'crocodiles' appeared on cue, and he had an enjoyable experience. But when he went on a boat trip in the wild, outside the theme park, he failed to see animals, they failed to perform, and he was disappointed by reality.

Baudrillard's vision of the theme park is perhaps more paranoiac but more politically pointed: 'Disneyland is there to conceal the fact that it is the "real" country, all of "real" America, which *is* Disneyland [. . .] Disneyland is presented as imaginary in order to make us believe that the rest is real, when in fact all of Los Angeles and the America surrounding it are no longer real, but of the order of the hyperreal and of simulation' (25). By presenting us with something that is obviously constructed – with Mainstreet, USA and so forth – we can be reassured that we have seen through an illusion, while ignoring the shift of the wider world into simulation.

The Simulacrum

The simulacrum is the fourth stage of the history of the image, or of the history of representation: the connection of an image to reality (or should that be 'reality'?). At first the image offers the reflection of a basic reality – Jameson discusses Van Gogh's painting of peasant shoes as this kind of image, where you become convinced these shoes are authentic and could almost be worn. Our perception of the image and of reality are here interchangeable.

The second stage is the one in which the image is a misrepresentation of a basic reality. Reality is perverted in the course of representation – it is shaped to be aesthetically pleasing, to offer good composition while underlying geometric frameworks are hidden. It might be a romanticised image of reality that pleases us with its beauty, or perhaps dirties it up to offer a grubbier version of reality to make us feel feelings of horror.

The third stage of the image is when the absence of reality is disguised or masked; we take something to be real when it isn't. In the construction of a film, for example, continuity of space and time is achieved by specific camera and editing techniques which bring events recorded on different days and locations together. In the television series *24* (2001-2003) an onscreen clock, split screen images and an authoritative voice-over tells us that the events of each episode take place during a single hour. We are blind to the missing fifteen minutes or so taken up with advertising – indeed that advertising offers us images which themselves disguise the absence of reality.

Finally in the fourth stage, the simulacrum itself, the image has no relation to any reality whatsoever. It is the digital image, the virtual world, the noughts and ones of computer codes. This too is the world of advertising, of the aura of cool which comes with purchasing a particular pair of shoes or eating a kind of breakfast cereal: eating *Health Crunch* and wearing the latest brand of casual footwear makes us look athletic – or at least part of the athletic society – therefore we *are* athletic. The image has overtaken and replaced reality. Politicians care more about opinion polls than they do about elections and polls are reported as if they are news. The stockmarket has turned not into a situation where demand and supply has an impact on how much commodities are worth, but a sort of high class betting ring where the measure of how much something is believed to be worth turns out to be how much something *is* worth. The money in our pockets and in our bank accounts is only worth what it is because we consent to it. The overtaking of reality by images points to a deferment of absolute meaning which will be discussed in the next chapter.

The Gulf War

Early in the 1990s, Iraq invaded Kuwait and the West threatened to use military might to liberate the country and eventually install a democratic régime in Kuwait. In a French magazine Baudrillard wrote an article called 'The Gulf War Will Not Take Place'. Nevertheless, it did. Baudrillard wrote a second article: 'The Gulf War Is Not Taking Place'. And yet briefings from General Schwarzkopf told us of tactical hits and the progress of the combined forces against Iraq. Finally the Iraqi forces withdrew, and the Americans decided not to topple Saddam Hussein after all. And Baudrillard wrote a third article: 'The Gulf War Did Not Take Place'. Clearly this is nonsense – a war did take place, thousands were killed. On the other hand Baudrillard claims, without evidence, that more people in the armed forces would have died in car accidents over the same period if there had been no war than actually did die in the war.

The reason the war could not take place was the end of the Cold War making war impossible. The Cold War and the Gulf War were about deterrence – in the Cold War the ability of both sides to destroy the other many times over made war itself inconceivable and impossible. In the issuing of ultimata from the UN in 1990 and 1991, there was so much sabre-rattling that war still seemed impossible, and Saddam's installation of a human shield again offered a logic of deterrence. Just as HIV ushered in an era of safe sex, so this would

be safe war; bastardising a sixties slogan, Baudrillard writes 'make war like love with a condom!' (26). This would not be a war, it would be a virtual war.

But America and its allies still had all these weapons, some of which were reaching their use-by dates and, well, if you're going to spend money on defence you need to use it every so often. It was not a war taking place, but an advert for the strength of Western military might, just as the Falkland Islands campaign a decade before had shown off missiles. Equally it made Saddam Hussein a charismatic figure, showed him holding the mighty West at bay. Of course, Hussein had been an ally of the West, the acceptable face of Islam, the pursuer of an unsuccessful war against Iran. Baudrillard remains unclear whether Hussein was punishing the West for his failure, or the West is punishing him, embarrassed by the failure of their training of his forces.

The war meanwhile, was not happening, or at least you couldn't be certain that it was happening. The Americans wanted to give the impression of a clean war, and the Iraqis helped them in this by setting up decoys that were bombed. Even so there was a mismatch between Western military capabilities and targets: 'The pilots no longer even have any targets. The Iraqis no longer even have enough decoys to cater for the incessant raids. The same target must be bombed five times' (53). By the time the British got to join in, everything else had been bombed.

At the end of the day, Saddam Hussein could be considered a hero: he showed American military might, improved public opinion of Israel and Iran, gave the UN a serious rôle in world politics, and granted Gorbachev a post-Soviet place in international affairs. War (non-war?) may have been '*the absence of politics pursued by other means*' (30), but it did have political consequences – although of course President George Bush failed to be reelected in 1992, being replaced by Bill Clinton who made neither love nor war, nor inhaled.

Of course, the Iraqis had blown up buildings to provide propaganda that the Americans were missing targets and that this was a dirty war. At the same time the West doctored pictures from satellites to show that it was a clean war after all. All of the war seemed to be fought by remote control: the Gulf War did not take place because the two sides never met: 'the two adversaries did not even confront each other face to face, the one lost in its virtual war won in advance, the other buried in its traditional war lost in advance. They never saw each other: when the Americans finally appeared behind their curtain of bombs the Iraqis had already disappeared behind their curtain of smoke...' (63). Of course, this kept Western casualties down, although it could hardly be

a proper war with such figures; meanwhile many more had died as a result of Hussein's internal policies, these casualties in time being eclipsed by the numbers killed as a result of sanctions.

It's difficult to know how seriously to take Baudrillard's account. Certainly there was disinformation, and the media feeding on itself – reporters (as well as generals) learning the truth from CNN. The war was certainly a spectacle, and its ending wasn't a Game-Over situation. When in 1999 there was another bombardment of Baghdad, there was the same fetishization of American and Iraqi missiles by the world's news crews. Labour veteran Tony Benn railed on one news programme against the aestheticisation of war, while the director cut to live footage of what could be mistaken for a fireworks display.

Gulf War denial on the part of Baudrillard may, of course, be an act of sustained irony, on a par with Swift's *Modest Proposal* (1729) which apparently advocated eating the children of the Irish poor to overcome famine and overpopulation. Or it could be a dangerous trivialisation of world events, which would not be found amusing by families of the casualties. It could show an absurd irresponsibility on Jean Baudrillard's part which risks discrediting the wider project of postmodernism.

4. Feminism, Gender And Camp

A Too-Brief History Of Feminism

The first feminism really occurred during the late Enlightenment, most particularly in the writings of Mary Wollstonecraft (1759-1797). In *A Vindication Of the Rights Of Women* (1792) she argued for women to be treated as equals to men and, in particular, that they should be educated alongside each other. There was a practical reason for this: she feared above all the dangers of pregnancy to the health of women – indeed she was to die as a result of complications from giving birth to a daughter, Mary Wollstonecraft Godwin (1797-1851), better known as Mary Shelley, author of *Frankenstein* (1818). Wollstonecraft's argument was that women would be treated less as wonderful objects or goddesses if men spent more time with them in their formative years; in addition education might give them better opportunities. As is typical in Enlightenment thinking, education will set you free; what is more interesting perhaps is how Wollstonecraft's intervention demonstrates that in the phrase 'All men are created equal', women are not included.

Little ground had been made, however, a century later when the suffragette movement began campaigning for the right of women to vote in Britain. It was not until 1918 that a few women were able to take part in elections and 1928 that all women over 21 could vote; in the United States the Nineteenth Amendment extended the franchise to women in 1921. Meanwhile some of the women associated with literary modernism were recording women's experiences or showing that they could be as modernist as their male counterparts – Dorothy Richardson (1873-1957), HD (Hilda Doolittle, 1886-1961), Edith Sitwell (1887-1964), Katherine Mansfield (1888-1923) among others. Virginia Woolf (1882-1941) wrote a number of novels – for example *Mrs Dalloway* (1927) and *The Waves* (1931) – which seem to push self-identity even beyond the kind of fracturedness which is considered as modernist, and argued for the development of a female sentence as distinct from the male. Jane Austen had developed one such kind, more than a century earlier, and both Woolf and Richardson developed new kinds of sentence.

There was another explosion of feminism in the late 1960s and 1970s, at the heart of the postmodern age; whereas the Enlightenment offered rights for men only, the counter-culture of the 1960s arguably offered free love for men only. A whole series of female writers and theorists exposed the centuries of oppression of women by men, and showed how it was still continuing; these

included Kate Millett (1934-) who wrote *Sexual Politics* (1970) and Germaine Greer (1939-) who wrote *The Female Eunuch* (1970). The mood was shifting from a demand for equality to the realisation that women would only be free in their own space, away from men (see, for example, the novel *The Female Man* (1975 but written some years earlier) by Joanna Russ (1937-)). Perhaps most notoriously there was Andrea Dworkin (1946-), who tirelessly campaigns against pornography as a kind of assault on women, and who argues that the legal status of marriage institutionalises rape.

Feminist theory, however, is not monolithic, being dividable into three major strands identified by the country that its originators were associated with: British feminism, which is interested in the material conditions of women and is largely associated with left-wing thinkers, American feminism, which seeks for the lost female voices of the past centuries, and French feminism, which draws on psychoanalytic criticism to uncover a feminine sensibility and consciousness.

Meanwhile the 1990s became a period of post-feminism and backlash. Two decades after attempts to legislate for equal pay, many men suddenly felt that they were the ones being discriminated against, in terms of pay, promotion and prospects. (This strikes us as being self-delusion of the highest magnitude.) Even many young, university-educated women – indeed not-so-young women – felt that feminism was not something that applied to them. By the end of the decade, the hard won freedoms of feminism allowed women to wear make-up, nail varnish and dresses – because they chose to – or to behave as badly as men – in the form of the drinking, swearing, belching, football-loving new laddette.

Madonna became an icon of postmodernity, in her unsettling performance of images of womanhood, wrapping herself in underclothes and brass bras, looking for all the world like a pornographic image Dworkin would wish to ban. But Madonna, apparently, is in control of the commodification of her sexuality, selling it for her own benefit. As the feminist critic Camille Paglia writes, 'Madonna is the future of feminism' (5). Paglia has no time for woman as victim, and attacks what she sees as the puritanical side of feminism represented by the anti-pornography movement.

Hélène Cixous (1937-) *and Julia Kristeva (1941-)*

The French feminist Hélène Cixous wrote of an *écriture féminine*, a cosmic, poetic, non-patriarchal language associated with women. This is a language that draws on the ideas of Jacques Derrida, in particular that of *différance* (which is not a typo, but a neologism intended to bring together the ideas of difference and deferment). This begins with the structuralist idea that language consists of signifiers (symbols or representations, whether visual or aural) and signifieds (concepts or ideas). We understand one particular signifier because it isn't another signifier. To take the signifier 'dog', we hear it as 'dog' because it is *different* from the sounds 'cog', 'dag' and 'dot', indeed from the sounds 'cat' and 'antidisestablishmentarianism'. Meaning is constituted through difference. But equally the signifier 'dog' can signify 'canine', 'follow', or 'telephone', and even the signified 'canine' seems to lead us to more signifiers: 'one of a family of flesh-eating mammals'. You look a word up in a dictionary, and you only get more words: ultimate meaning is deferred – and indeed always different. *Écriture féminine* is a language which is open, and attempts to liberate meaning rather than pin meaning down.

Concepts often occur together in pairs – light/dark, good/evil, convex/concave, active/passive, sun/moon – which for Cixous map onto the master opposition male/female or masculine/feminine. This is a kind of oppression. But *écriture féminine* can resist and undermine such hierarchies and provide an alternative to the patriarchal system (or metanarrative?) without itself being a system.

This finds a parallel in the ideas of the Bulgarian-born Julia Kristeva, who worked in France, and modified Lacanian psychoanalysis – itself a kind of psychoanalysis via semiotics – to offer a new form of feminist thought – one that to some extent is sceptical about the whole notion of woman.

Jacques Lacan had argued that identity was constructed through and in language. The child, rather than experiencing an Oedipal fear or hatred of the father, becomes aware of the symbolic power of the phallus which the mother desires. The child wishes to become the phallus for the mother, but is prevented from doing so by the process of castration anxiety. For Lacan, then, the male child enters into what is known as the symbolic order, and the systems from which society is constructed (family, politics, the social and so forth), until such time as he can perform the rôle of the phallus. The already castrated female child, on the other hand, cannot truly enter the symbolic order, which is patriarchal in structure, and so has to retreat in nostalgia to a time before the Oedipus complex.

Kristeva concentrates on the alternative to the symbolic order, a shadow language which is not rigid, hierarchical and rational, but which has been seen as babble and is called, by Kristeva, the Semiotic. This is the language of the repressed, the oppressed, the suppressed, the forbidden, the marginal and the dissident. In other words, precisely the language which might be thought of as suitable for patriarchally repressed women. If women cannot speak the language of men, they can speak the language of babble.

This risks collapsing gendered identity down into a kind of essentialism: there is something which is essentially male or essentially female about a kind of language. Just as Cixous prefers the notion of writing associated with women to female writing, so Kristeva argues that the semiotic is not in itself gendered. Cixous' examples of practitioners of *féminine écriture* include the blokes James Joyce and Jean Genet (1910-1986), and Kristeva is interested in the *avant garde* writers Antonin Artaud (1896-1948), Louis Céline (1894-1961) and James Joyce, among others. To associate the female with the feminine is simply to collaborate in the work of patriarchy. Woman, as such, does not exist; she is constructed. Here, again, we reach another moment of confusion: Kristeva might be thought to offer a postmodern feminism, but she does so through considering modernist writers.

The Abject

Much of postmodern thought deals with unsettling oppositions (writing/ speech etc.) or skating along boundaries. Kristeva's work on the notion of the abject is also about boundaries. Abjection turns out to be at the root of much of society, our social structures, our religions and our aesthetics. Abjection is perhaps an attempt to draw a boundary, but which fails.

A good example of abjection used by Kristeva is the skin that forms on the top of milk: 'When the eyes see or the lips touch that skin on the surface of milk – harmless, thin as a sheet of cigarette paper, pitiful as a nail paring – I experience a gagging sensation and, still farther down, spasms in the stomach, the belly; and all the organs shrivel up the body, provoke tears and bile, increase heartbeat, cause forehead and hands to perspire' (2-3). Think about the custard made at school and poured into the jug, and how, as the milk cools to blood temperature, a membrane forms, firm to the touch, slightly feathery, and before you know it, the server has stirred the custard in a vain attempt to destroy it... It will come back, of course, when you least expect it; you take what you assume to be liquid into your mouth and instead something solid coats itself across your tongue...

The skin on milk, on gravy, and so forth remind us of the fragility of our own bodies, perhaps of an earlier, more contented self. The abject is neither part of us, nor entirely separate from us. The abject can be further located in urine, blood, sperm, excrement, mucus, saliva, sweat, all liquids which have once been part of our bodies, and are expelled from us: they all result in a sense of disgust, which seems to be part of an attempt to police the body and its boundaries. These liquids can hardly be alive and yet certainly aren't dead; the abject can also be seen in vampires, in zombies, and in other borderline identities.

The abject disrupts all boundaries.

Post-Gender

Most feminist critics have tried to avoid an essentialist notion of what it is to be woman, but in this postmodern world we've realised that the two alternate solutions of separatism (finding a different space in which to be a woman) or attempting through increased equality to find emancipation (liberation is illusory because it is on contested ground) are not solutions after all. The solution is to find a post-gender world. In Haraway's 'Manifesto For Cyborgs', discussed in the next chapter, the cyborg alternative to being a goddess is one such attempt to think beyond gender. Gender is a metanarrative that justifies patriarchy.

Perhaps we could argue that there is a biological bottom line of dangly bits and orifices, or pairs of chromosomes. Except of course male chromosomes only appear to be deformed female chromosomes and an increasing percentage of the population are born without a determinable sex. Animals remarkably far up the evolutionary ladder can change sex (without surgery) or operate asexually.

If sex is simply an illusion, then gender is simply a social construction. Indeed, over centuries notions of manliness have changed – at one point a kind of dandyness was the ultimate in masculinity and at another all that outdoors stuff was felt to be, well, dubious. Pink was once the colour for a boy. The French cultural commentator Michel Foucault argues that self-identity is not something fixed and eternal, but at different points in history we have created a specific conception of race, sexuality, madness, and criminality. Homosexuality, for example, became a kind of defining self-identity in about 1869. Simone De Beauvoir (1908-1986) argues that 'one is not born a woman, one becomes one', and indeed the concept of woman had to be invented.

37

Both feminine and masculine behaviour are thus performances rather than identities, just as Madonna or David Bowie performs a particular identity. Some women may actually choose to behave 'like a woman' in order to reassure men that they are not a threat to them (see Marilyn Monroe's character in *Gentlemen Prefer Blondes* (1953)), and sometimes men performing masculinity don't seem masculine at all (see Tick in his cowboy shirt in *The Adventures Of Priscilla, Queen Of The Desert* (1994)). From this point of view, drag is not something which should be condemned by feminists as degrading of women, but celebrated as something which demonstrates the performance that is gender.

Susan Sontag's 'Notes On Camp' (1964)

Susan Sontag (1933-), an American novelist, screenwriter and essayist, set down 58 notes trying to define camp, in part as an asexual identity. Camp is life lived in quotation marks, the world seen as a performance, and seeks pleasure in the artificial, because there is no such thing as nature anymore. While she may give earlier examples, she situates the start of camp as being in the Eighteenth Century, and, while she doesn't use the word, this is the period of the Enlightenment. This was the age of rationality, of seriousness, whereas 'Camp is art that proposes itself seriously, but cannot be taken altogether seriously because it is "too much"' (note 26).

Again Sontag doesn't use the word, but camp seems to be a kind of postmodern aesthetic. The abandonment of sincerity that camp proposes seems to suggest a waning of affect, and the celebration of style over substance is part of the sense that camp 'incarnates a victory of "style" over "content", "aesthetics" over "morality", of irony over tragedy' (note 38). There are objects that are taken to be camp (naïve camp) and those which try to be camp (deliberate camp).

This is where problems begin to set in. The former is privileged over the latter: 'Camp which knows itself to be Camp ("camping") is usually less satisfying' (note 18) and 'Probably, intending to be campy is always harmful' (note 20). Camp is a matter of taste but it is the taste of 'an improvised self-elected class, mainly homosexuals, who constitute themselves as aristocrats of taste' (note 50). On the other hand 'if homosexuals hadn't more or less invented Camp, someone else would' (note 53). Her descriptions of homosexuality are rather grudging, and she is cagey about crediting camp to them. On the other hand, there is a danger in eliding homosexual identity with a camp aesthetic.

Camp has perhaps become the dominant aesthetic since the film of *Batman* (1989). Even prior to the TV series, Batman and Robin had been outed as a homosexual couple, and nothing that the later, darker versions of the story can do – encasing its closeted heroes in rubber – can quite shake it. *Batman* and its sequels are just far too serious for their own good. Meanwhile all kinds of cartoons and sitcoms are given the big screen, big budget treatment from *The Brady Bunch* (1995) to *Scooby Doo* (2002) to the TV remake of *Randall And Hopkirk (Deceased)* to ersatz 1960s icons like Austin Powers.

5. Science Fiction

The New Wave

Genre science fiction began in the magazines in 1926, drawing on precursors such as Mary Shelley (1797-1851), Edgar Allan Poe (1809-1849), Jules Verne (1828-1905) and HG Wells (1866-1946), but largely subjugating style and characterisation to plot and ideas. If there was a postmodern core to this sf, it was that life could be otherwise, that the world was only how it was due to arbitrary decisions, and that a story that revealed this seemed incapable of being taken seriously as literature. In the 1950s a few stylists emerged in the genre – Theodore Sturgeon (1918-1985) and Alfred Bester (1913-1987) being perhaps the best – where the prose could offer as much pleasure as the ideas.

In the 1960s, the writers of sf began to reinvent the wheel. In Britain a group of writers wanted to reinvigorate sf by rejecting the clichés of alien invasion, apocalypses, spaceships and the can-do spirit. One of these, JG Ballard, wrote a guest editorial for the British magazine *New Worlds* in which he argued that: 'science fiction must jettison its present narrative forms and plots [...] it is *inner* space not outer, that needs to be explored. The only truly alien planet is Earth' (117). Within two years, Michael Moorcock (1939-) had become the editor of the magazine, and provided a space for this new kind of sf, which became known as (British) New Wave science fiction. British writers such as Moorcock, Ballard, Brian Aldiss (1925-), Barrington Bayley (1937-), John Brunner (1934-1995) rubbed shoulders with Americans such as Thomas M Disch (1940-), John Sladek (1937-2000), Pamela Zoline (1941-) and Norman Spinrad (1940-) who were sympathetic to this *avant-garde* project.

Ballard had written disaster novels such as *The Drowned World* (1962) in which the protagonists (hardly heroes) seemed liberated by the apocalypses rather than oppressed, and embraced their dooms; similarly Disch wrote novels where humanity wasn't saved from the alien invasions. John Sladek, like Disch an American resident in London in the late 1960s, produced pastiches of other science-fiction writers, and designed a number of forms which induced anxiety and paranoia. John Brunner, in a series of disaster novels, turned to the model of American author John Dos Passos (1896-1970), using many different viewpoint characters and including newspaper clippings.

The British critic and sf author Colin Greenland (1954-) initially failed to see these writers as being postmodern: 'British New Wave sf is one more

example, or rather many more examples, of the anarchic and ill-defined movement that critics have tried to label "absurdist", "comic-apocalyptic", "Post-Modernist" or even "Post-Contemporary" fiction, "surfiction", and "fabulation"' (203). Greenland was probably thinking more of post-modernism in the architectural sense, of postmodernism as double-coded and eclectic, which would have been the dominant sense of the term in the late 1970s when he was writing. He adds: 'Sf could be interpreted, with some condescension, as a new Gothick, the popular expression of the Modernist's Angst' (53). Sf has been located, by Brian Aldiss among others, as part of the Gothic tradition, a tradition antithetical to the Enlightenment ideals, and thus you might have thought not modernist. Greenland has since changed his mind, arguing that the New Wave 'was the white-hot slurry of garage postmodernism' (9).

Cyberpunk

The American critic Fred Pfeil (1949-) understood the New Wave as a much more American moment, still including Ballard and Disch, but adding Philip K Dick, Joanna Russ and Ursula Le Guin (1929-). These authors also paid particular attention to style and experimented with form, but were also influenced by discussion of gender and sexuality. In books like *The Female Man* Russ was finding a feminine écriture for sf, fracturing the subjectivity of her protagonists, incorporating quotations from other works and having direct addresses from the author to the reader. Pfeil sees this 1960s new wave as the moment where sf 'briefly becomes modernist' (85-6), but this is so he can create a space to discuss postmodern sf in the shape of cyberpunk.

One origin of the word 'cyberpunk' is in the title of a short story by Bruce Bethke (1955-), which was published in *Amazing* in 1983. Another is in the critical writings of Gardner Dozois (1947-), the editor of *Isaac Asimov's Science Fiction Magazine*. The term came to cover quite a diverse movement of writers who explored notions of virtual space – cyberspace – in near-future settings often dominated by multi-national corporations. The real world settings were usually rain-swept, polluted city streets, populated by pushers, prostitutes, conmen and gangsters. This was a low down and mean and dirty future, which reached an immediate high water mark in *Neuromancer* (1984) by William Gibson (1948-), a Dashiell Hammett-tinged caper about the rescue of an Artificial Intelligence by a hacker who is hostage to poison sacs sewn into his bloodstream. Gibson's writing style can be characterised by its dependence on surface over depth, being dense and poetic, always assuming that the

reader is as familiar with the world as the author is and so never stopping to explain.

Gibson's version of cyberpunk came to be the dominant form, and was echoed in stories and novels by writers such as Rudy Rucker (1946-), Pat Cadigan (1953-), John Shirley (1954-) and, much later, Neal Stephenson (1959-). But there is also a strain of cyberpunk which is more biological, typified by the writings of Bruce Sterling (1954-), especially *Schismatrix* (1985). In form the novel was a classic sf type – the future history – but its characters were largely prosthetically-enhanced Mechanists or genetically engineered Shapers. His characters were thus posthumans, who can either be seen as the ultimate development of humanity (late humans?) or a break with humanity.

Sterling's place within the history of cyberpunk is essential, and one singularly underplayed by Andrew M Butler in his Pocket Essential on *Cyberpunk* (2000). In there he wrote that 'Two writers tower above the cyberpunk movement as its central visionaries: Gibson the break out writer, and Sterling the polemicist', having noted Sterling's introduction to his collection *Mirrorshades* as one key place for defining cyberpunk, and Sterling's columns in British magazine *Interzone*. What Butler inexplicably omits from his account is Sterling's widely circulated fanzine, *Cheap Truth* (1983-1986), edited as by Vincent Omniaveritas, which did much to demarcate cyberpunk while critiquing, even demolishing, earlier science fiction. Oddly, cyberpunk isn't even mentioned until issue 12, and in the final issue Omniaveritas effectively declares cyberpunk to be dead, with *Mirrorshades* as its tombstone: 'I hereby declare the revolution over. Long live the provisional government.' The cutting edge of sf had passed before anyone had really noticed. Sterling also described an anti genre, slipstream, which was writing which estranges the reader: neither sf nor realist, but having a postmodern sensibility. Authors labelled as slipstream include Ballard and Disch, as well as Peter Ackroyd (1949-), Iain Banks (1954-), Peter Carey (1943-), Jonathan Carroll (1949-), Russell Hoban (1925-) and so forth.

Cyberpunk And Postmodern Theory

Postmodernism's emergence as aesthetics occurred at the same time as the recognition of cyberpunk, and a renewed spurt in taking science fiction seriously. *Science Fiction Studies*, a left-leaning academic journal edited in North America, partially embraced postmodernism, and certainly postmodern thought, but that was only to be expected. What was less expected was the willingness of academic journals like *Critique*, *Mosaic* and *South Atlantic*

Quarterly to take cyberpunk seriously. Cyberpunk's explorations of the notion of the posthuman – whether AI, cyborg, genetically-engineered or mechanically enhanced – appealed to a generation of academics who wanted to leave their bodies behind. (We think that much of cyberpunk actually has a romanticised notion of the body.)

This academic interest reached its peak in conferences in 1995 and 1996 at Warwick University, UK, then one of the enclaves of incomprehensible theory in Britain. Many attendees seemed to want to be real cyberpunks, and wore fetish-like costumes. Various theorists who seemed to have taken leave of their senses rubbed shoulders with Orlan, a woman who was to have her entire body remodelled to demonstrate perfect beauty (complete with video footage of her operations) and Stelarc, a rather personable Australian who used to hang himself by meat hooks and who now sported a remote controlled prosthetic arm, and had explored his own interior space by means of a submarine which could be swallowed. While many of the attendees were knowledgeable about postmodern thought, for far too many of them cyberpunk began and ended with *Neuromancer*.

More useful writers on cyberpunk with a postmodern slant are Istvan Csicsery-Ronay Jr, Joan Gordon and Veronica Hollinger, all currently editors of *Science Fiction Studies* and Brian McHale, who had discussed Philip K Dick in his book *Postmodernist Fiction* and incorporated chapters on cyberpunk in *Constructing Postmodernism*. Csicsery-Ronay Jr sees cyberpunk as 'the apotheosis of bad faith, the apotheosis of the postmodern' (193) and discusses the Hipness of cyberpunk. *Mirrorshades* includes writers that Csicsery-Ronay Jr doubts are really cyberpunk in any meaningful sense, or indeed whether they are the same kind of hip. Cyberpunk does operate in the realm of the schizophrenic, of the hallucinatory, with transcendence via technology – but fails (like postmodernism itself) to be fully aware of the politics of both technology and the control of technology.

Gordon attempts to find a space for feminism in cyberpunk – a subgenre which seemed to be dominated by male writers. Cyberpunk offered a covert space for feminist thinking, and the journey to the underworld myth, which occurs in many cyberpunk works, offers a potential for exploring feminine identity as the journey narrative offers a metaphor for the journey of or into the self. Hollinger fits cyberpunk into a tradition of antihumanist sf. In cyberpunk there 'is an overwhelming fascination, at once celebratory and anxious, with technology and its immediate – that is *unmediated* – effects upon human being-in-the-world' (205). The impact of networked technology is to dislocate the individual from time and space – cyberpunk undermines the subject and

subjectivity, it is about the death of the self. But she also feels that structurally cyberpunk 'could only go so far before self-destructing under the weight of its own deconstructive activities (not to mention its appropriation by more conventional and more conventional writers)' (217) – in other words being hip to the Zeitgeist might draw the attention of those who wish to commodify your artform and it's difficult for any punk movement to remain counter-cultural when its members are best-sellers. She also notes that one dominant paradigm of sf – fallen man under the thumb of technology – is not the only myth. The cyborg can be a hopeful monster.

Donna Haraway's 'Manifesto For Cyborgs'

The word 'cyborg' is a coinage for '*cyb*ernetic *org*anism' and refers either to a person who is enhanced by technological means or to a machine with a human brain. Cyborgs became central to many sf movies of the 1980s and beyond – the *Terminator* and *Robocop* films, as well as much straight-to-video material. For Donna Haraway, though, the cyborg became a political identity. The cyborg identity at the point when a whole series of oppositions had been destabilised: the human and animal, the human/animal and machine, and the physical and the non-physical, symptomatic of the deferment of absolute meaning, which will be discussed in Chapter Seven.

In part this goes back to the crisis of legitimation noted by Lyotard: for Haraway much science is sexist and racist and rigidly polices difference in terms of self-identity: race, sex, sexuality, class and so forth. The result is that female identity has been sidelined either into something that is beyond comprehension, or something which needs to be worshipped. Woman has become goddess, charged with the magical rôle of motherhood. The answer is not simply to overturn the hierarchies because that would simply repeat the original error in a new form. Like Derrida, she wants to deconstruct identity – indeed she notes that race, sexuality and even sex are concepts which have been developed at particular points in history. The cyborg is one such deconstructed identity. It evades the narratives of Oedipus and the Fall, it cannot seek for reunification of the self because it was never unified in the first place. It is a stage of evolution, a regeneration rather than a (re)birth and offers a vision of a post-gendered (post-sexed) world. Haraway would rather be a cyborg than a goddess.

6. Postmodern Texts

253: Or Tube Theatre

1996. Written by Geoff Ryman. Online: www.ryman-novel.com. *253: The Print Remix*, London: Flamingo, 1998.

At 8.35 am on 11th January 1995 a Bakerloo line train containing 252 passengers and one driver left Embankment Station. At 8.42 the train crashed though the barriers at Elephant and Castle Station. This is the story of those 253 people.

Except, of course, there was no crash then, it's an alternate history of sorts, and the idea that there are exactly 252 seats and 252 passengers on a Bakerloo line train, evenly distributed, is clearly fantasy. Nevertheless, this is the task that Ryman has set himself, describing their appearance, thoughts and actions in 253 words each, and inviting us to follow the hyperlinks between the characters when they have things in common. Take as an example passenger 179, Ms Annabelle Rowan, about 40, who is reading Jeff Noon's *Vurt* (1993) and has learned things from a Bhagwan in Oregon; Mr Martin Belcher, 34, (passenger 49) served a biker customer yesterday who is planning a trip in Oregon. Belcher is reading *The Independent*; Miss Estelle Irtin (167) is a reader of *The Independent On Sunday*, which printed a photo which caused her to fall in love with Saddam Hussein... and so forth.

Geoff Ryman has a cameo, as passenger 96, an amateur actor taking part in *Mind The Gap*, a theatrical production for a small paying audience which takes place on the tube. Ryman was meant to stand up while an accomplice takes his seat, before sitting on him. Unfortunately Ryman sits on the wrong lap, and then has to make the mistake a second time to return to the script. A watching actor is uncertain whether this is a performance (the timing was just too good to have been rehearsed) or the actions of a buffoon. Ryman narrowly escapes being arrested.

The constriction of 253 words is in the Oulipo ('Ouvroir de littérature potentielle') tradition of limitations on styles or structures in writing, generally considered to be modernist rather than postmodernist, having been started by chess-playing mathematician François Le Lionnais and author Raymond Queneau in France in 1960. One example is George Perec's *La Disparition* (1969) which lacks the letter 'e' throughout. Some people insist that *The Great Gatsby* (1925) is similarly structured, but this is wrong. Presumably they are thinking of Ernest Vincent Wright's *Gadsby* (1939). Another cousin

to *253* is Peter Greenaway's *The Falls* (1980), 92 vignettes of people whose names begin Fall—, and who are connected to birds in bizarre ways. (Greenaway chose 92 in homage to a favourite film-maker who had 92 scenes in a film. Alas, Greenaway miscounted.)

253 caused a stir as an interactive internet novel, being constructed in addictive bitesized chunks, and somehow being an advance on all those *Choose Your Own Adventures* which appeared in the late 1970s and into the 1980s. A print version followed, for reading on the tube and elsewhere, and became Ryman's best-selling book to date. He takes the opportunity to have a dig at HarperCollins (parent company of the Flamingo imprint) for remaindering his earlier titles and even provides a reader satisfaction survey at the back. A sequel, *Another One Along In A Minute*, is promised, to be co-written with his readers: the train behind the one that has crashed is stuck in a tunnel for three hundred seconds, and contains three hundred people, to be written about in three hundred words each. It has yet to appear on the website or in print.

His earlier fiction is also worth a look, beginning with *The Unconquered Country: A Life History* (1986), a fantasy fable about or set in Cambodia. *'Was...'* (1992) also mixes fantasy and realism.

The Adventures Of Baron Munchausen

1988. Directed by Terry Gilliam. Starring: John Neville (Baron Munchausen), Sarah Polley (Sally).

Terry Gilliam has long been a director for whom the dream is more significant than reality, though you'd have to go back to Orson Welles (or maybe Ed Wood) to find a director whose dreams were so thwarted by reality. He had to fight to get his final cut of *Brazil* (1985) released in the US, *Munchausen* spiralled over budget due to misleading accounts, and one project after another (especially his *Don Quixote*) has bitten the dust before or during filming. *Munchausen*, the third part of a loose, 'Three Ages of Man' trilogy with *Time Bandits* (1981, childhood) and *Brazil* (adulthood), is precisely about this kind of collision.

In a city besieged by the Turks, a theatre company performs a play in a bombed out theatre about the adventures of Baron Munchausen, only to be interrupted by an elderly man who claims to be the real Munchausen, who started the war. With the aid of the stowaway Sally, daughter of the actor manager of the theatre, he sets about trying to end the war, in the process rounding

46

up his old team of companions. The journey takes him up to the moon, down to Vulcan's volcano and into the mouth of a huge fish. Unfortunately he is killed in the attempt, but this is only one of the many ways in which he died and the Turks have been vanquished after all.

The eighteenth-century setting puts the action precisely at the heart of rationality, with a literal clash of metanarratives between the Judeo-Christian West and the Islamic Turks. However the two sides have reached an eminently sensible rapprochement: there are schedules of bombardments and counter attacks, and they take it in turns to surrender. One soldier is executed for extreme bravery; such actions would be upsetting to his companions. This is war run by accountants and logicians.

The unlikely tales of Munchausen seem so much more the ravings of an old man in this context, as we all know that there is no man in the moon and that there are no gods – especially gods manufacturing weapons of mass destruction as part of a process optimising the campaign of war. Nor is it particularly likely that the Baron would get younger as the excitement builds nor that he would find all his former acquaintances. But the story is seductive.

That rationality should be rejected is endorsed by the thrust of the film's narrative: the Turks *are* defeated, although it is unclear how. Munchausen defeated them but was then killed, and the fact that he is here to tell the story, suggests that the story of routing the Turks was indeed a story. In the story of how the war began, the camera moves from performance on a stage to the Sultan's palace in a single pan, eliding the shift from reality to story, and we are led to believe that this story ends and then Munchausen sets out on his mission. In fact the majority of this narrative is the story within the story, potentially an irrational work of fantasy. Nevertheless, the story works, and the Turks have mysteriously gone.

A sense of ambiguity also hangs over the end of Gilliam's comedy-modernist updating of *Nineteen Eighty-Four* (1949), *Brazil*. Sam Lowry (Jonathan Pryce, who later plays the accountant mayor in *Munchausen*) has been captured and is about to be tortured when he is rescued by rebels and is able to escape into a country idyll with his new girlfriend. The camera pulls back, to reveal a tortured Sam, who has escaped from his body into his dreams. In the meantime we are left to ponder the fate of all the major characters who were depicted in the previous dream sequence.

Breakfast Of Champions,
Or Goodbye Blue Monday

1973. Written by Kurt Vonnegut Jr. New York: Delacorte.

Kurt Vonnegut Jr was born on Veteran's Day 1922 in Indianapolis and was interned as a prisoner of war in Dresden when the Allies bombed it in February 1945. Few other writers have so consistently appeared in their own fiction, and tried to blur the line between their persona and their character. The Dresden experiences found their way into *Slaughterhouse-Five, Or The Children's Crusade: A Duty-Dance With Death* (1969), where Vonnegut briefly interacts with his leading character, as well as promising a friend in the preface that he wouldn't portray the war as heroic. In *Breakfast Of Champions* Vonnegut is writing his novel as he turns fifty, bringing together a car dealer Dwayne Hoover and hack sf writer Kilgore Trout, as well as providing his own infantile drawings to illustrate the book.

Kilgore Trout's name perhaps suggests science-fiction writer Theodore Sturgeon, and Trout in part expresses Vonnegut's uneasy relationship with the genre. Early novels such as *Player Piano* (1952) and *The Sirens Of Titan* (1959) used sf to satirise contemporary society; the latter focused in part on predestination and the inevitably of life – and introduced the Tralfamadorians who would also appear in *Slaughterhouse-Five*. In the *Sirens* the evolution of the Earth turns out to be a message to a stranded alien about a missing spare part. Trout first appears in a non-sf novel, *God Bless You, Mr Rosewater* (1965), as the favourite writer of the titular character; Trout's output is immense, full of insight and invention, but is largely published in pornographic magazines. In *Breakfast Of Champions* he is a little more battered, but has a great future ahead of him, including winning the Nobel Prize for medicine and gaining world fame. At the end of the novel Vonnegut sets him free – as Tolstoy and Jefferson freed their slaves when they turned fifty – but by the time Vonnegut wrote the Nixon-era satire *Jailbird* (1979) Trout was back (a pseudonym of another character) and his ghost haunts *Galápogos* (1985). A novel even appeared bearing his by-line – *Venus On The Halfshell* (1975), which answered the question of why humanity is created only to suffer and die, and was actually written by Philip José Farmer. Trout's likely final appearance is in *TimeQuake* (1997), a final novel by Vonnegut about the much better novel, *TimeQuake*, he had spent ten years trying to write.

In *Breakfast*, one of Trout's books causes Hoover to run amok: *Now It Can Be Told* reveals that the rest of humanity are machines, but only he has free-

will so the Creator can see how he behaves. Vonnegut sees himself as a machine for writing novels, his mother as a machine designed to kill herself and so on. Vonnegut prepares us for the events long before they happen, as if they are meant to happen (and he has decided they will happen, building up characters to allow the narrative to work).

While Vonnegut's humour is very dark, there is hope. In *Breakfast* an artist sees each of us as a beam of light. In *Slaughterhouse-Five* it is possible to concentrate on just the happy events. *Cat's Cradle* (1963) suggests that we should cling to harmless lies if they make us happy, and therefore to embrace irrationality. We are also part of a group of significant people who have made us the way we are, for better or worse. In *Slapstick, Or Lonesome No More!* (1976) everyone is given a new middle name which allows them to form family bonds with the strangers who share this name. None of this is logical, but it is about the most we can do in a doomed world.

The author as character seemed to be a popular conceit in the 1960s and 1970s – compare Robert Sheckley's *Options*, as well as a couple of novels by Tom Robbins: *Even Cowgirls Get The Blues* (1976) in which the author celebrates reaching chapter one hundred and *Still Life With Woodpecker* (1980), a love story set in a packet of Camel cigarettes, and a battle between Robbins and his brand new typewriter. He finally finishes the novel longhand. In Richard Brautigan's *Trout Fishing In America* (1967), the main character is *Trout Fishing In America.* Vonnegut is the author of many speeches, newspaper and journal articles and pamphlets of a humanitarian, anti-war, bent, some of which are collected in *Wampeters, Foma And Granfalloons* (1974), *Palm Sunday: An Autobiographical Collage* (1981) and *Fates Worse Than Death: An Autobiographical Collage Of The 1980s* (1991). One college graduation speech was attributed to him, and circulated on the internet, before being made into a hit record 'Everybody's Free (To Wear Sunscreen)' by director Baz Luhrmann. In fact the piece was a semi-spoof column written by Mary Schmich for the *Chicago Tribune* June 1 1997. (The single remixed Quindon Tarver's 'Everybody's Free (To Feel Good)' with Sydney actor Lee Perry reciting the words.)

Cerebus The Aardvark

1977-2004. Written and illustrated by Dave Sim. Backgrounds by Gerhard. Kitchener, Ontario: Aardvark Vanaheim.

The comic book medium is the lowest of the low: poor quality illustrations that make a mockery of art, appalling prose, and pulp adventure narratives. Even the most famous of these – *Superman* (1938-, created by Jerry Siegel and Joe Shuster), *Batman* (1939-, created by Bob Kane and Bill Finger) and *Spiderman* (1962-, created by Stan Lee and Steve Dikto) – seem like adolescent fantasies where real life powerlessness and angst is juxtaposed with caped avenging and masked crimefighting. The uncanny similarity between the concept of such supermen and the Nietzschean *Übermensch* has not gone unremarked, not least in some of the comics themselves. *Watchmen* (1986-1987, written by Alan Moore, drawn by Dave Gibbons) is set in a world where superheroes are real, and a nuclear apocalypse is nigh. Here we have superhero as sociopath. The Batman in Frank Miller's *The Dark Knight Returns* (1986) is also outside of society, and takes the opportunity to satirise both the vigilante and the psychologists from the 1950s who condemned comics for their depictions of violence and sublimated homosexuality.

Cerebus began life as a satire of the barbarian hero genre, as typified by Conan the barbarian, with a greedy, smelly, cantankerous and sexually charged aardvark as the central character. It was intended that the comic should be a biography of the hero, in three hundred monthly instalments, and Dave Sim undertook to self-publish all the issues to maintain artistic freedom. While initially Cerebus undertook various missions to win gold and confronted dark spirits, a political edge came to the fore, as did a commentary upon power structures and notions of religion. On the one hand there was a critique of feminism (as well as a character who looked like Margaret Thatcher), on the other hand Sim told the story of the death of Oscar Wilde (or a fantasyland equivalent), thus featuring the first explicitly gay character in non-underground comics. Sim also draws on many sources for his characters, parodying other superheroes in Wolveroach, and stealing the likenesses of the Marx Brothers and grannies from British newspaper cartoons. One issue even recreated a classic sequence from *A Night At The Opera* (1935).

Comics are often accused of being infantile but when they attempt to deal with adult concerns (such as the *2000AD* spin-off *Crisis*) they are condemned as being unsuitable for children. As the series of — *For Beginners* books, some renamed *Introducing* —, have proven, complex ideas can be introduced and explained using a combination of words and pictures. In 1988 Alan

Moore edited a collection called *AARGH!* (*Artists Against Rampant Government Homophobia!*) to raise awareness and money to fight the British Conservative government's attempt to introduce Clause 28, an anti-gay law. The medium has thus long since come of age.

Crash

1973. Written by JG Ballard. London: Jonathan Cape.

James Graham Ballard was born in Shanghai in 1930 and spent much of the Second World War interned by the Japanese with his parents. After coming to Britain, he started a degree in medicine and then became a writer in 1956, publishing his early stories in science fiction magazines, including the British *New Worlds*. After a guest editorial in *New Worlds* in 1962 in which he demanded that science fiction explore inner rather than outer space, he became the central figure in the British New Wave of science fiction which also included Moorcock, Aldiss, Sladek and others. He produced a series of disaster novels with apparently downbeat endings – *The Drowned World* (1962), *The Drought* (1965) and so forth – and he started writing densely constructed condensed novels which were collected in *The Atrocity Exhibition* (1970). Many of these featured versions of the same protagonist, T—, in different guises and were overshadowed by the assassination of John F Kennedy, the image and death of Marilyn Monroe, the Vietnam War and the explosion in the media landscape which occurred during the 1960s.

Crash returns to a more centralised narration and begins a new, suburban, trilogy of disaster novels which continues with *Concrete Island* (1974; man trapped on a traffic island) and *High-Rise* (1975; the breakdown of society in a new community). It is the account of a man who, having survived a near-fatal road accident, becomes obsessed with cars, car crashes and the erotics of wounds. In the nebulous zone around the north west of London – London Airport, the north circular, the Westway, Drayton Park, the motorways – he encounters prostitutes and other victims, he views the spectacle of the crash test dummy family, and Dr Robert Vaughan, another obsessive who is plotting to crash his car into Elizabeth Taylor at the moment of her orgasm. If this were not disturbing enough, the narrator of the novel is one James Ballard.

Given how much a car can be an index of a man's virility (one of us once saw a poster of some shiny red sportscar, defaced with the graffiti 'Dis is a willy'), it is hardly surprising that cars can prove erotic – and Ballard sees *Crash* as the first pornographic novel of technology. It is a difficult work to

stomach, as the human body and its orifices are laid out before us in clinical detail, and the characters use each other's infidelities – real or imagined – as foreplay. Ballard takes a shocking notion, and runs with it for the course of the novel.

According to Baudrillard, '*Crash* is the first great novel of the universe of simulation' (319), and elsewhere he writes that '*Crash* is our world, nothing is really "invented" therein, everything is hyper-functional: traffic and accidents, technology and death, sex and the camera eye. Everything is like a huge simulated and synchronous machine; an acceleration of our own models of all the models which surround us, all mixed together and hyper-operationalized in the void' (312). For Baudrillard the wounds, physical or psychic, which permeate the novel are not examples of anxieties about castration but rather a series of invaginations, a token of ritualistic sexuality akin to the practices of some Aboriginals.

When *Crash* was published, Ballard suggested that it was a warning about the seductiveness of technology, and it had an admonishing function; more recently he has rejected this. Pornography (if we accept this designation for the novel) has long had tradition of claiming a moral high ground or an educative function – *The Naked Lunch* claims an antidrugs message, for example. But what is perhaps more interesting is that *Crash* has been taken up by some critics as the key text – a marriage of nightmare and reason to paraphrase Ballard's introduction – which explains all of Ballard's works. Precisely the same was argued of *Empire Of The Sun* (1984) a quasi-autobiographical account of Jim Ballard's life during the Second World War which was seen as the retrospective source of the imagery that suffuses his works, and to a lesser extent of *The Kindness Of Women* (1991), which retreads and reimagines the same ground: the making of a film of *Empire Of The Sun* and his own apotheosis as a huge billboard in California.

Like many of his generation of sf writers, Ballard oscillates between seeing science fiction as the literature of the age, and railing against critics who make too many grand claims for it. At times Ballard is perhaps closer to the Surrealists than to his fellow genre hacks, being fascinated by the absurd, the dream image and the juxtaposition of objects. For Fred Pfeil he was 'the author of an unprecedentedly *literary* SF, one full of brilliant impressionistic imagery and psychological insight' (85) and his writing or 'some other [unspecified] prompting' marks the point when sf 'briefly *becomes modernist*' (85-6). Ballard's embrace, whether in terms of imagery, tone or experimental form can mark a modernist avant-garde, but this avant-garde always threatens to topple over into postmodernism. Jameson discusses his work, briefly, in *Postmod-*

ernism, Or The Cultural Logic Of Late Capitalism, seeing his novels being precisely about the emergence of a postmodern aesthetic. According to Scott Durham, Ballard anticipates many of Jameson's ideas about postmodernism, and the history of postmodernism is 'inconceivable' (46) without Ballard and William S Burroughs.

Generation X: Tales For An Accelerated Culture

1991. Written by Douglas Coupland. New York: St Martin's.

Something strange happened in America between 1965 and 1977. The generation born after the war – the babyboomers – had never had it so good and lived during a period of unprecedented economic expansion and prosperity. Things were not so good for the generation which followed, the babybusts – children of the midsixties and after who grew up watching the sell-out of their hippie parents and came of age in the age of AIDS after living in the shadow of the bomb. There was nothing to rebel against since their parents had been counter-cultural and then conformist, and there was no chance of getting a job that was worth sticking at: flipping burgers or clerking at a convenience store for minimum wage. This is a media-savvy generation, ironically seeking solace in *The Brady Bunch* (or *The Magic Roundabout*) and aware of being targeted and defined as a demographic.

Generation X by Douglas Coupland (1961-), along with Richard Linklater's film *Slacker* (also 1991), did much to map the Zeitgeist. Coupland's book – somewhere between a novel and a short story collection – is set in 1991 or later (the dates don't quite add up) and is Andy's account of his underachieving life, and that of his friends Dag and Claire, on the borderline of consumer society. The Zeitgeist doesn't demand a narrative or doesn't stretch to one, but instead the characters tell a series of micronarratives to each other (a fin de millennial *Canterbury Tales*?) of greater or lesser import, while slacker slogans and definitions of lifestyles nestle for space in the margins or the footers of the book. An appendix gives the stark statistics about social pessimism: the decline in job satisfaction, in the number of people in work, the number of twenty somethings married or wanting to marry.

Meanwhile the same generation re-enact *Jaws* in salsa and argue about the Deathstar in *Clerks* (Kevin Smith, 1994), go out and hang at the mall in *Mallrats* (Smith, 1995) or even get to draw their own comic books in *Chasing Amy* (Smith, 1997). In the first two films the characters don't get to be consumers, save of beverages and cookies, and occupy the mall as a social space rather

than contributing to the economy. After all, by the mid-1990s the mall had come to be a utopian space – for mallrats, for office workers who try but don't buy at lunchtime and for senior citizens who exercise by walking up and down the aisles. The slackers fall on their feet in *Chasing Amy*, temporarily seizing the means of production to produce comic books before facing the choice of selling out to corporate America and going for the TV series (and it is a sell-out, as the events of Smith's *Jay And Silent Bob Strike Back* (2001) reveal).

For by the mid-1990s Generation-X were being lapped, by the Next Gen or the N Gen, a new generation which embraced capitalism apparently uncritically. At the height of the internet boom teens and twenty-somethings became emillionaires, or worked as programmers for computer games companies, throwing all of their efforts into these companies, as their hobbies were their jobs and vice versa. There was no need to worry about long term prospects and promotion: you'd be burnt out by 25.

Rob Latham's book *Consuming Youth: Vampires, Cyborgs, And The Culture Of Consumption* (2002) is a fascinating exploration of the fiction and theory surrounding the youth culture of the last twenty-five years or so, in part exploring vampire texts such as *The Lost Boys* (Joel Schumacher, 1987) and *Generation X* and its successors. Latham notes how a whole generation is turning itself into cyborgs, whether through becoming a couch potato, symbiotic with the remote control, or through the mouse into the Infobahn. He steers a middle course between high minded rejection of popular culture as typified by (Marxist) Critical Theory and the uncritical acceptance of anything the kids make use of, which is inherent in some recent cultural studies. There is space for resistance to capital here, as well as the thrill of allowing oneself to be seduced by it.

'The Gernsback Continuum'

1981. Written by William Gibson. First published in Terry Carr, ed., *Universe 11* (New York: Doubleday).

Cyberpunk has to begin somewhere, and perhaps it should begin with William Gibson's first published story – although like most of the stories in *Mirrorshades* it hardly seems to be the real (subgeneric) thing. Here a photographer is assigned to photograph an America that might have been, the America of pulp magazine covers, all rocketships and graceful curves, the New York World's Fair's vision of the 1981 that was to come, and has yet to

be. Having found gas stations which resemble the vision, he begins to halluci-nate vast, twelve-propped airplanes that had once been imagined, and what's more is able to photograph them. A friend suggests he exorcise these 'semi-otic ghosts' by immersing himself in the trash culture of pornography.

This offers us a curious nostalgia – for the art of the 1930s and 1950s, which is understandable on their own terms, but also a nostalgia for the 1980s. Such nostalgia was later to be identified by Jameson as a characteristic of the postmodern aesthetic in films like *Blue Velvet, Something Wild* and Dick's *Time Out Of Joint* (see Chapter Two). This latter offers an unacknowledged blueprint for Peter Weir's *The Truman Show* (1998) where Truman (Jim Car-rey) is the infantile character who discovers his 1950s-style, idyllic, small town has been built for his benefit, as part of a television reality show. Indeed it offers a similar ontological structure to *The Matrix* (1999) where Chicago is a delusion for an enslaved humanity who are really batteries (no, really). In turn, extradiegeticly, Sydney stands in for Chicago.

The titular Gernsback of Gibson's story, meanwhile, is never there explained, although clearly it is a reference to Hugo Gernsback (1884-1967), author of *Ralph 124C 41+* (1911-1912), coiner of the term 'scientifiction' and founder editor of the first sf pulp magazine, *Amazing Stories* (1926). Gerns-back put great emphasis on science and technology (he had been editor of *Modern Electrics*), especially as something which was possible, and there is the sense he wanted to help create the world his writers imagined.

Greg R Letham (1952-)

Born in Boston, Lincolnshire, UK, Letham is an artist who has explored surfaces more deeply than virtually any other. He has passed through a series of phases in his career, each of which has been characterised by its exploration of depthlessness. Unlike many conceptual artists, he has remained faithful throughout much of his career to painting, although he has often used media other than canvas and paint. He came to notoriety in the mid-1970s with his recreation of Renaissance paintings without the sense of perspective that the old masters brought to their commissions. Sometimes reminiscent of the Pre-Raphaelites, Letham saw himself as a Pre-Giottoite. Arguments raged over whether he brought perspective into question or whether he was merely incompetent.

He retreated from painting for half a decade, but worked instead in con-crete, sometimes scooping out things to make images, sometimes using

objects – including himself – to make impressions. As the early 1980s wore on, he used thinner and thinner concrete, and fewer objects, ending with *Red Shoes* (1983), where there is hardly an impression of shoes having been there at all unless it is lit in the right direction. The next year saw *Blue Shoes* (1984), a Polaroid of the damp patches left by a pair of shoes (presumably blue) which had trodden in a puddle.

This was a brief phase, as the years 1984-1992 saw a return to painting on flat surfaces, in what was a culinary phase. On Shrove Tuesday each year he made up a batch of pancake batter and used this to create his canvas; in later years he even used coloured batters to make collages with. Many of his best works only survive as Polaroids, since it was in the nature of his art to be edible. The rest of the year Letham refused to paint, claiming that it was Lent.

His last major exhibition (1998) was a homage to Baudrillard: a series of windscreens, some whole, some shattered, from his attempt to drive from Land's End to John O'Groats. His desire was to show the residue of collisions with insects, but his refusal to accept the randomness of such events led to charges of dangerous driving. A rumour that he was going to release thousands of flies into the gallery at the press launch proved thankfully nothing more than that.

In the past few years he has returned to painting, and used various objects to crush and flatten paintings. Inspired by Michael Lally, who famously crushed all his belongings in an empty shop in Oxford Street, London, he has been trying to raise money for an industrial compactor, but has been distracted by the possibility of paper shredders – hoping to do for the art of shredding what David Hockney has done for fax machines.

Gremlins 2: The New Batch

1990. Directed by Joe Dante. Starring: Zach Calligan (Billy), Phoebe Cates (Kate), Christopher Lee (Dr Catheter).

There is an argument to be made that Joe Dante is the central director of postmodernism. No other director steers such a consistent course between parody and the genre which inspires a work – with the aid of John Sayles's scripts, *Piranha* (1978) undercuts *Jaws* (1975) and *The Howling* (1980) parodies the werewolf genre, while still providing the thrills you'd want. Dante demonstrates an affection for the popular culture of the 1950s – which aliens have learnt language from in *Explorers* (1985) and which is the backdrop to *Matinee* (1993), a love letter to earlier exploitation cinema. Dante learnt his

craft working for Roger Corman's low budget movie making company, and effortless produces rich meaning from low, exploitative material. He continues to cast actors from the Corman stable, especially Dick Miller, and finds space for cameos from Corman and Sayles. Wes Craven is his nearest parodic rival, in the *Scream* trilogy which satirises the slasher genre while attempting to provide examples of it; slasher movies have always been pastiches though, with *Halloween* (1978) borrowing from *Psycho* (1960).

The plot itself hardly matters, as allusion follows allusion. A gremlin atop a model of the Empire State Building, below a mobile of biplanes, evokes the climax of *King Kong* (1933), while Gizmo reinvents himself, *à la* Rocky. References abound to Jekyll And Hyde, The Phantom Of The Opera, *Godzilla* movies, Dracula, Batman, *The Wizard Of Oz* and Quatermass. In one shot Christopher Lee's character Dr Catheter (homage to Hammer horror films?) is carrying a pod from *Invasion Of The Body Snatchers* (1955) and declares 'The Horror! The Horror!', referencing Conrad's *Heart Of Darkness* (1902) or more likely *Apocalypse Now* (1979). In the background *It's A Wonderful Life* (1946) is playing on TV monitors, and *Casablanca* (1942) is announced, now in colour and with an even happier ending.

Gremlins 2 followed the financial success of *Gremlins* (1984). In the first film Billy is given a cute gremlin, Gizmo, and warned not to get him wet or feed him after midnight. Naturally both happen, and Gizmo reproduces ugly, malevolent gremlins, which take over and devastate the Capra-esque small town. Half a decade later, *Gremlins 2* ups the chaos and the parodic content, relocating to New York and having Billy and his girlfriend Kate working for Clamp Industries, in a state of the art, security camera infested skyscraper. Clamp wishes to build a new community in New York, in the process tearing down the block where Gizmo and his elderly Chinese 'owner' live. Gizmo is acquired by Clamp, only to be rescued by Billy – but in the process Gizmo again gets wet and malevolent gremlins take over the building. Fortunately Billy knows what to do and Gizmo, having seen *Rambo*, is fighting back.

At one point the film apparently breaks down, jamming in the projector and burning up, and shadow puppets appear on the screen thanks to the gremlins. Meanwhile the film offers a self-critique: Leonard Maltin appears as himself to review the video release of *Gremlins*, condemning the movie before he himself is attacked by gremlins. And as Billy tries to persuade the corporation of its danger, and why these creatures should not be fed after midnight, various executives raise objections, about where on the world midnight needs to be, about timezones and so forth.

It is a shame that Dante is not more regarded. His loving homages are underappreciated. His plot structures, subjects and characters – there is usually a child or teen protagonist aided by a wise old man – suggest somehow that these are mostly children's movies, while the violence and effortless sophistication are more suitable for adults. *Small Soldiers* (1998) offered an anti-war, anti-corporate satire which ended up by suggesting that everyone has their price. Alas the film failed to appeal to child or adult audiences. The time is right for re-evaluation of this postmodern *auteur*.

The Larry Sanders Show

1992-1998. Created by Garry Shandling and David Klein. Starring Garry Shandling (Larry Sanders), Jeffrey Tambor (Hank Kingsley), Rip Torn (Arthur).

Garry Shandling had previously appeared in a postmodern sitcom, *It's Garry Shandling's Show* (1986-1990), set in and around his living room, which just happened to include a studio audience – an idea later used by Sean Hughes for *Sean's Show. The Larry Sanders Show* if anything blurred the boundaries between fiction and reality even more, being set in a talk show hosted by Larry Sanders and featuring actors such as Alec Baldwin, Billy Crystal and Dana Carvey playing 'themselves'.

Much of American television drama has come to hinge on the distinctions between work and home life – the Family and the family in *The Sopranos*, the reserved and the hedonistic in *Six Feet Under* – and *The Larry Sanders Show* is no exception. It contrasts the smooth talking, flattering, aggrandising sphere of the celebrity interview where everyone is loved and everyone's work is marvellous with the backstage gossip and backstabbing. Sanders is vain, self-centred and pompous, eternally worried about his image, and fearful of being upstaged by the celebrities his career inevitably leaches off. His eternal sidekick, Hank, is always trying to advance himself by flattering Larry, while doing down guests and co-workers in case they usurp his place in the pecking order. And then when the show is back on air, professionalism is all.

Not only do we see into Larry's private life (which mostly seems to consist of rewatching his shows while in bed with a series of attractive women, including his celebrity guests) but we appear to see the way that celebrities work, and glimpses of their private lives; these lives presumably being manufactured for the sake of the show. David Duchovny, for example, lusts after Sanders across a number of episodes, an action at odds with his married man

image. We do see the guests plugging their wares – Crystal talking about *Mr Saturday Night* (1992) – but we are just as likely to cut quickly to the commercial break or to after the show. In one episode, the stars (in particular Courteney Cox) are sidelined by Sanders' attempt to mirror David Letterman's use of his crew on his talkshow; Sanders stages interviews with his gossiping head scriptwriter and his sour guest booker – which are of course played by those who perform those functions in the production office. As Arthur, the foul-mouthed, tough-guy producer, warns, they are crossing the talent moat between talent and non-talent, and the whole office want to become celebrities too. David Letterman, playing himself watching the show at home, can only look on in horror.

The sitcom chatshow crossover can also be seen in *Knowing Me, Knowing You* featuring the incompetent Alan Partridge (Steve Coogan) and fictional guests, *The Mrs Merton Show* with Caroline Aherne playing the pensioner with a sharp line in questioning, and the various incarnations of Ali G who made a fool of the attempt to be hip by politicians and celebrities.

Lies, Inc

1964. 1965. 1979 or 1981. 1984. Maybe. Written by Philip K Dick. And John Sladek. London: Gollancz.

This is perhaps a perverse choice of novel, but a book on postmodernism that didn't mention Dick would be like one that didn't mention that movie with Harrison Ford in. Perhaps we ought to discuss *Time Out Of Joint* or *The Man In The High Castle* (1962), which Brian McHale praises for its ontological playfulness, or *The Three Stigmata Of Palmer Eldritch* (1964), name checked in *eXistenZ* (1999), or *Ubik* (1969) which Peter Fitting says deconstructs bourgeois sf (whatever *that* means). We could go on.

Instead we have a novel which, like almost all of Dick's, questions what it is to be real and what it is to be human. What's more, it questions what it is to have an authentic text. In 1964, Dick was commissioned to write a novella for *Fantastic*, called 'The Unteleported Man'. This was a story of Rachmael ben Applebaum who is convinced that the colony world of Whale's Mouth is some kind of prison or death camp, and decides to travel there by ship to prove it (rather than by teleport, hence the title). In 1965 Dick was then commissioned to write a second part to the story – to take it up to novel length – but as it was an account of a drug trip (Rachmael teleports across to join a war when Whale's Mouth's true status is revealed and is shot by an LSD-tipped

dart), the editor rejected it and published what he already had. There the matter might have rested, although at one point Ray Nelson said he was going to collaborate with Dick on a novel called *Whale's Mouth*.

In 1983, the year after Dick's death, the complete version was finally published, although it actually wasn't complete, as four manuscript pages had been mislaid in the intervening years. Still, it was nice to have more Dick in print, the earlier editions of *The Unteleported Man* being long out of print. What Berkly books didn't realise was that in 1979, or perhaps in 1981, Dick had gone back and rearranged that manuscript, adding a new first chapter and moving the part two to a point two-thirds into part one. Rachmael fools his enemies by *not* travelling in the spaceship but teleports to Whale's Mouth in disguise, only to be shot by an LSD-tipped dart and to begin to hallucinate. After various bizarre events, Rachmael is sentenced to death, but fortunately escapes via a time machine disguised as a tin of condoms, ending back on his ship, as if the events of the previous pages hadn't happened (although the war he hasn't fought in has been won. So far, so Munchausen). As if this wasn't bad enough, although shifting the material had removed one of the gaps, it still left two missing pages, which were filled in by John Sladek, sf writer, humorist and parodist, who had been highly praised by Dick. The four pages have since been located, but not published in any edition of the novel.

Naturally this changes the meaning of the book, and it becomes uncertain quite what is going on. The characters of Whale's Mouth can look themselves up in a history book, to look at their pasts and their futures, as well as what is happening to friends and enemies. This would suggest a world of predestination, except that we learn that there are various versions of the history book (although we learn that in one of the lost passages, so we don't know if that is true). Or it might all be a plot by time travelling UN assassins, who are trying to kill neo Nazis. Confused? It's the only way of being certain you understand what's going on.

The Life And Opinions Of
Tristram Shandy, Gentleman

1759-1767. Written by Laurence Sterne. York: self-published (volumes one and two); London: R and J Dodsley (volumes three and four); London: T Becket and P A Dehondt (volumes five to nine).

Sterne (1713-1768) was an Irish clergyman living in York who wrote what is arguably the first postmodern novel. Purporting to be the autobiography of

the eponymous Shandy, it is so complete that it takes until book three for him to actually be born, having started at the moment of conception in chapter one. Partly he is delayed as his readers pose questions or make objections, but mostly because he tries to put everything in. Unfortunately this means that he is living at a much faster rate than he can write. He does attempt to counter this by covering a huge distance and several years in one chapter, but he loses it by having entire chapters set on a staircase, or indeed a chapter about chapters (perhaps, says Shandy, the best chapter in the whole book) or by tearing an entire chapter out of the novel.

The digressions into legal issues, into excommunication, into battles and architecture, into fable (and suddenly remembering to do a preface in book three) show an apparently vast array of knowledge (some of it directly (mis)copied from an encyclopedia) and plays with what a novel should be, before the form had really settled down. In a parallel to this process, his maimed uncle Toby attempts to recreate battles, at times seemingly as big as the real thing. This is one of many hobby-horses ridden by the male characters in the novel, the term hobby-horse referring both to the notion of pastimes and to prostitutes (who are ridden in different ways). The death of Yorick the vicar (in part Sterne's alter ego, and Yorick's sermons are Sterne's) prompts two black pages in mourning, a device which would not be out of place in Alasdair Gray's *1982, Janine* (1983), where blank pages indicate the narrator has passed out. The modernist novel *Ulysses* (1922) could not have been written without it – more proof that a work has to be postmodern before it can be modern. (The interrupted narrator is a device which is used elsewhere, perhaps to best effect in *The Princess Bride* (1987) where Columbo tells a story to a sceptical kid from *The Wonder Years*.)

A constant text of reference is 'An Essay Concerning Human Understanding' (1690), by John Locke (1632-1704), which argues that the child is a blank state onto whom things are written by experience and through perception. Locke's rationalism is a precursor to the Enlightenment period, being just too early to be part of the period proper, and he also suggested that states were governed by the consent of the people, the consent to be withdrawn if need be. Shandy's rationalism is perhaps too rational to be entirely rational...

Living in Oblivion

1995. Directed by Tom DiCillio. Starring: Steve Buscemi (Nick), Catherine Keener (Nicole), James Legros (Chad).

Film-makers have often turned to film-making for their subject matter, just as novelists end up writing about authors, and often appear as characters in their own books. This needn't in itself be enough to earn the pomo watermark: *The Man With A Movie Camera* (1929) is perhaps too relentlessly modernist, and too unironic in its setting up the Cameraman as the Hero (although that seriousness may in itself be ironic, and the audience get to watch an audience). Vincent Minnelli's *The Bad And The Beautiful* (1952) offers a satire on the Hollywood process at the heart of the studio system, but Hollywood seems to like having its hand bitten. Robert Altman's *The Player* (1992) is nearer the mark, with its mixture of star actors playing directors, actors, writers and producers, as well as cops, and other actors acting themselves (compare *The Larry Sanders Show*). Characters even discuss extended takes during an extended take. Or see the Coen Brothers' *Barton Fink* (1991).

Tom DiCillio's low budget *Living In Oblivion* is another example, as maverick director Nick attempts to shoot a single scene in his latest movie, and everything goes wrong: the boom gets in shot, there is noise outside the studio, the camera isn't in focus, and the actors keep forgetting their lines. One particularly successful (and obnoxious) actor, Chad, is only in the movie because he thinks Nick is a mate of Quentin Tarantino – and Buscemi who plays Nick was a highlight of *Reservoir Dogs* (1991).

We have been wrong-footed from the start though. The film mixes black and white with colour footage: the former for the set, the latter for the film being made. In *The Wizard Of Oz* (1939) black and white had constituted reality, and Technicolor, Oz, whereas in *Wings Of Desire* (1987) black and white was how the angels saw, colour was the real world. Here both formats are fantasy: the entire opening sequence is Nick's nightmare of the day's shoot. It seems to break all the rules, since we see things that Nick would not actually see, and even a flashback for his lead actress, Nicole. Nor, indeed, is the second scene to be shot, from a film called *Living In Oblivion*, any more real. It is just another nightmare. So the final section, an attempt to shoot a dream sequence, complete with Fellini-esque dwarf and malfunctioning smoke machine, can hardly be real. Hollywood has often been called the dream factory; independent film is a dream cottage industry.

Buscemi steals many a low budget movie for maverick directors, and indeed can make a bad Hollywood movie watchable (aside from *The Wedding Singer* (1998), which is beyond redemption). His performance in *Armageddon* (1998), briefly alongside Peter Stormare, merely reminds the audience how much better *Fargo* (1995) is. Keener had been in DiCillio's *Johnny Suede* (1991), a bizarre film with Brad Pitt, and went on to co-star alongside the ever reliable John Cusack and the surprisingly good Cameron Diaz in *Being John Malkovich* (1999), in which it is never entirely clear whether Malkovich is meant to be the real John Malkovich and whether Charlie Sheen is entirely convincing as Charlie Sheen.

Keener reappears in DiCillio's *The Box Of Moon Light* (1996) and his other film world satire, *The Real Blonde* (1997), which again mixes hallucination with reality. It's worth watching for its demolition of *The Piano* (1993) alone. (After all, you move a piano across a room and it needs retuning. Are we expected to accept that one can go halfway across the world and sound like Michael Nyman as soon as it's out of its box?)

The Man Who Wasn't There

2001. Directed by Joel Coen. Starring: Billy Bob Thornton (Ed Crane), Frances McDormand (Doris Crane), James Gandolfini (Big Dave).

Joel and Ethan Coen have long toyed with noir – *Blood Simple* (1983) and *Miller's Crossing* (1990) both seem like adaptations of James M Cain or Dashiell Hammett, and *Fargo* (1995) returns to the narrative, the tone, and even some of the scenes of *Blood Simple* in parts. All of these have family betrayal at their heart, whether literal family or the metaphorical family of gangsters. But when blackmail, extortion or murder is committed to extract money, the scheme either backfires or has unintended consequences. *The Big Lebowski* (1998) seems to have the ghost of Chandler/Hawks's *The Big Sleep* (1946). *The Man Who Wasn't There* returns to Cain territory, in lugubrious black and white. It also continues their obsession with crazy haircuts and fat men who shout (Gandolfini is convincing as Big Dave, bringing some sense of *The Sopranos* with him, while we could imagine John Goodman in the rôle).

The 1940s, Santa Rosa, California. Ed Crane is a barber, married, not entirely unhappily, while his wife does the accounts for and has an affair with Big Dave, manager of a local department store, Nirdlinger's. One day Crane cuts the hair of Tolliver, who convinces him that he should invest in a dry

cleaning business. Ed doesn't have the money, and so decides to blackmail Big Dave about the affair. While Ed gets the money, things don't go quite as planned, and a series of deaths occur, with people being punished for these events, and Ed ends up in the electric chair – a chair which suddenly reminds you of a barber's chair.

Sam Raimi's *Crimewave* (1985) also puts its antihero in an execution cell, but manically retraces his steps of how he got there in the hope that there might be a last minute pardon. The pace in *The Man Who...* is snail like, as we listen to Ed tell his story in voice-over, while Ed in person hardly says anything. He has been asked to write his memoirs (very *Kind Hearts And Coronets* (1949)) for a pulp magazine, so we are very much being told his *version* of events, and largely the action does stay with him. But in the first trial we have the hot shot lawyer, Freddy Riedenschneider, from Sacramento (everything, private investigators, shawls for catching hair, comes from Sacramento in this movie) who doesn't like Ed's version of events, and doesn't like Doris's version of events, and decides to build on a private eye's version of events. He tries to use Heisenberg's Uncertainty Principle as a defence – which basically refers to observing atomic particles and the limitations on how much you can know about them – to argue that the closer you look, the *less* you know, and, well, having looked closely at the situation...

The film contains numerous references to *noir* films. Nirdlinger's refers to a character in James M Cain's *Double Indemnity* (a character name), renamed as Diedrickson in the film version (and here a county coroner). Riedenschneider echoes a name in WR Burnett's *The Asphalt Jungle* (film 1950). The Hobart Arms features in *The Big Sleep*. A drowned man found in a car echoes both *The Night Of The Hunter* (1955) and *The Big Sleep*'s missing chauffeur (although we *do* know who killed him this time). Hitchcock – who comes from the same Expressionist tradition that influences *film noir* – may provide the title (*The Man Who Knew Too Much* (1934/1955)) and the theme (the wrong man).

At the same time, it seems to be one of the most Philip K Dickian narratives yet committed to film, in particular *The Broken Bubble* (written 1956) and *Confessions Of A Crap Artist* (written 1959). Both share a sense that there is hidden adultery beneath the surface of an otherwise respectable California, and people get hurt as a result. The correspondences are even more striking on the level of characters. Dick re-uses four basic character types. The typical protagonist is what Andrew M Butler has called a Serviceman, stuck in a dead end job working for someone else – an engineer, a tyre regroover, a policeman – probably impoverished, bored, trapped and hapless. If he is married, it is

usually to a woman who does not understand him, a castrating harpy or Bitch figure – although it has to be noted that Dick also depicts intelligent women trapped in the rôle of housewife. The Serviceman is often distracted from his wife by a younger woman, often Dark-Haired, described as if she is a spirit of femininity, with particular attention paid to her breasts. Sometimes she will rejuvenate the hero, sometimes she will leave him even worse off. The fourth recurring character type is the Patriarch, either a biological father or a leader or boss: sometimes these are wise, kindly figures, sometimes they are dangerous tyrants who compete for the attentions of the Dark-Haired Girls, sometimes they oscillate between the two.

Ed is the serviceman, the barber, Doris his wife the harpy, Rachael the *Lolita*-esque, piano-playing daughter of a friend is the dark-haired girl and both Big Dave and Riedenschneider are patriarchal figures. Even Big Dave's wife's belief in UFOs and government conspiracies is not out of place; in *Confessions* Jack gets sucked into a group that believes in aliens and the upcoming end of the world. Ed's attempts to help Rachael match Jim Briskin's attempts to help Art and Rachael in *The Broken Bubble*. Even some of the themes – what is a man, what is reality – can be located in the film and Dick. In a sense it wouldn't matter if it were pointed out that the Coen Brothers never read a Dick novel in their life; the film can be liberated from their preferred reading, and re-read as something else entirely.

(Hey, did you read Alex Irvine's review where he suggested you took this without acknowledgement from Kim Stanley Robinson's book on Philip K Dick? *I did read it, but I'd already come up with the scheme long before I read Robinson. But what can you do? Respond to a review and look like a fool.* What, like now? *Quite.*)

Michael Nyman (1944-)

Someone once said that writing about music was like dancing about architecture – and neither of us can dance. But music demonstrates postmodern traits as much as any other cultural expression and often in a more popular format. There is a kind of strain of British eccentric observational surrealism that runs from The Kinks through Madness to The Beautiful South and Blur, where there is an ironic affectionate depiction of English life. Madonna (and to a lesser extent Elvis) have been put forward as postmodern icons, the former being seen as the ultimate feminist icon. Other pop acts and bands are held to be postmodern because of their kitsch value, or because they are open to camp strategies of appreciation. The psychedelic and glam bands also lend

themselves to such readings, in the case of The Velvet Underground and David Bowie offering deliberate camp (and the former came out of Andy Warhol's art scene).

Computer and synthesiser technology from the late sixties to the present day offer us a range of simulations of music. Tangerine Dream, German pioneers, offered electronic soundscapes but never entirely abandoned guitars, although melody was often absent. The rhythmic texture fed via other bands (German and otherwise) into the various techno music genres where music is measured in beats per minute. Meanwhile sampling techniques allowed riffs and tunes to be stolen from other musicians and made part of a new track, which would transform into something entirely different in the remix process. (At one conference we attended, some practitioner theorists were joyous about the white label status of many of these records; you didn't know who had produced the record, so there was no cult of personality in the way of the music. At the same time, without acknowledging the contradiction, they said that they could identify from the sound who had produced them. So much for the death of the subject.)

Much of the history of popular music has been the history of appropriating African American music from Blues to Soul to Rap. The apparently misogynistic, homophobic, anti-authoritarian, pro-violence stance of many rappers is rightly taken seriously – although in some cases it has to be acknowledged that this is as much a pose as being a space alien in the 1970s. The real moral panic began when the white rapper Eminem began gaining international chart success, and also sang about how commercial pressures might change his music. Ironically his concerts are being attended by an increasing number of middle aged people, presumably themselves obsessed with appearing to be young, but beginning the process of domesticating his rebellion.

Meanwhile Michael Nyman has been more quietly postmodernist, although like the movie *Velvet Goldmine*, he needs to be played loud. In the 1960s as a music critic he coined the name 'minimalism'. The musical avant garde had shown an interest in twelve note composition, known as serialism, and wrote music which slowly elaborated the same basic phrase; composers include Karlheinz Stockhausen (1928-) and the later Igor Stravinsky (1882-1971). The basic development process of serialism, but within a limited range of tempi, pitches and rhythms, led from this to minimalism, best represented by the music of John Cage (1912-1992), Terry Riley (1935-) and Steve Reich (1936-) through the 1960s and 1970s.

Nyman's own compositions, especially his soundtracks, seem to mix sampling with minimalism, in that he will often take a bar of music from an earlier composer such as Mozart or Purcell. Peter Greenaway suggested he write 92 variations of bars 58-61 of Mozart's *Sinfonia Concertante for violin, viola and orchestra* to form the soundtrack of *The Falls* (1980); Nyman used the same pattern in subsequent scores, ripping off himself. The entire movement forms the basis for variations for his soundtrack to *Drowning By Numbers* (1988). Nyman's music is often used by directors as a temp soundtrack to their movies, to give the composer some inspiration as to what the director wants; Nyman has thus often been asked to compose like himself. He has also written music for videogames. Mozart never did that.

Moulin Rouge

2001. Directed by Baz Luhrmann. Starring: Nicole Kidman (Satine), Ewan McGregor (Christian).

Christian, a young poet, has gone to Montmatre, Paris, at the turn of the twentieth century to find love and inspiration; in fact he finds a troupe of actors wanting to get Harold Zidler, the manager of the Moulin Rouge club, to fund their show, *Spectacular Spectacular* and ends up as their writer. This leads him to attempt to seduce the star of the Moulin Rouge, Satine, in the hope that they can get funding, at precisely the point that Henry offers Satine to a wealthy Duke in the hope of getting his investment. Alas, Satine mistakes Christian for the Duke, and chaos and tragedy ensue as Christian and Satine improvise a plot for *Spectacular Spectacular* about forbidden love.

This is the third of what Luhrmann has called his Red Curtain films – films which splice melodramatic plot (love across ethnicity, across class) where the audience knows the outcome of the story with a revelling in artifice – which heightens the style and distances the audience from it. While *Strictly Ballroom* (1992) begins as documentary, the stylisation of dance mitigates against any sense of realism. Similarly, the iambic pentameter of *William Shakespeare's Romeo + Juliet* (1996) heightens the portrayal of a very modern feeling story, cut like a pop promo (of course, Leonard Bernstein's *West Side Story* had paved the way). In *Moulin Rouge* the heightening/distancing is provided by the use of music – not an authentic recreation of 1890s music but versions of pop and rock hits from the last fifty years. The sight of an unusually portly Jim Broadbent singing Madonna's 'Like A Virgin' is worth the entrance fee alone. Satine is part of a group of singers styled the Diamond Dogs (a nod to David Bowie) which leads to Satine's rendition of 'Diamonds Are A Girl's

Best Friend'. The soundtrack also includes medleys of love songs, Nirvana's 'Smells Like Teen Spirit' and a host of others, as well as references to *The Sound Of Music* (1965) and Bollywood.

Just as in the earlier films emotions were expressed through dance or rhythmic verse, so here love and thoughts about love are expressed through lyrics; feelings are performed rather than demonstrated. At the heart of this is Nicole Kidman, and her portrayal of the courtesan. Just as in *Eyes Wide Shut* (1999), there is something cold and distant about her performing style which makes it impossible to quite believe that she is in love with Christian or she is the siren she is presented as. Mythologically speaking, of course, she is Euridyce to Christian's Orpheus, and just like him, he loses her in the Underworld he is trying to rescue her from. She is dying from tuberculosis – a disease of nineteenth century melodrama and opera like *La Bohème*.

Luhrmann's ambition is audacious, from the opening curtain and a conductor conducting the Twentieth Century Fox theme before segueing into 'The Hills Are Alive', to Christian and Satine dancing across a Parisian skyline complete with moon borrowed from George Méliès to a complex intercutting of two separate scenes to 'Roxanne'. Through all this, of course, the affect is flattened rather than waned, and the sublime has rarely been so hysterical. But there is always the sense that each character is a puppet and, while the songs work, they could just as well have been other songs.

The Naked Lunch

1959. Written by William S Burroughs. Paris: Olympia Press.

William Burroughs (1914-1997) was an influence long before he was published, on the new literary movement of the Beat Generation, especially Jack Kerouac and Allen Ginsberg. He had been born into a wealthy background, and went to Harvard University, but dropped out of mainstream society and became a heroin addict. While living in Mexico City he accidentally shot and killed his wife, in a so-called William Tell routine. His first publication was an Ace Double, *Junkie* (1953, as by William Lee), an account of his drug experiences, and at the same time he wrote about his homosexuality in *Queer* (not published until 1985).

The Naked Lunch (more usually known as *Naked Lunch*) was written in north Africa, and sent in sections to Allen Ginsberg, who arranged for Olympia Press to publish it. The book is essentially a collection of what Burroughs called routines – semi-satirical accounts of drug addiction, hallucinations,

police investigation, sexual acts, bodies being transformed, alien encounters and so forth. In a sense it is a book that can read at random, dipped into, rather than necessarily read through from cover to cover. Like a number of books of the period – Hubert Selby, Jr, *Last Exit To Brooklyn* (1964) – publication around the world was accompanied by obscenity trials.

The surrealist feel of the novel was emphasised in further novels by his use of cut-ups – which re-ordered his words – and fold-ins – which incorporated the words of others and gave the feel of a drug trip to the experience of reading the works, as well as explicitly drawing on earlier avant garde writing techniques. Novels such as *The Soft Machine* (1961), *The Ticket That Exploded* (1962) and *Nova Express* (1964) added science fiction elements – there had been Mugwumps in *Naked Lunch*, now joined by Venusians – and indeed were published occasionally as science fiction, and viewed language as a virus which was infecting the world. His work was also characterised by a sense of paranoia – about the police and other security forces, about who runs the world, about the number 23, and so forth, suggesting how the far right was using the international drugs crisis to set up international policing and repression.

His later fiction also drew upon maritime novels, boys' adventures, westerns, as well as noir fiction remaining prominent throughout. Having situated himself in his early fiction as William Lee, Burroughs created a series of alter egos within his fiction, who one by one were killed off. By the time of *The Place Of Dead Roads* (1984) and *The Western Lands* (1987) he had written his way beyond death; indeed as he was the only major writer of the Beat Generation to still be alive when he had abused his body with drugs for decades it seemed for a while as if this were true.

Burroughs was an influence upon the British New Wave of science fiction, especially JG Ballard, and on cyberpunk, especially William Gibson. His shattering of taboos no doubt allowed for sexually explicit works such as those of Robert Cooper. A film version of *Naked Lunch* was talked about for many years, and Burroughs was involved in film-making when in Britain in the 1960s. Anthony Balch got as far as drawing storyboards for the project. Cronenberg's film version is far too linear, focusing on the experiences of William Lee, and is careful to bracket the more surreal sequences within the trips of Lee on sniffing bug powder. It also draws heavily on Burroughs's life story, including the William Tell incident.

Options

1975. Written by Robert Sheckley. New York: Pyramid.

Robert Sheckley was born in New York in 1928 and is one of the great comic science fiction writers, cited as an influence by Douglas Adams (*Dimension Of Miracles* (1968) features a manufacturer of planets a decade before Magrathea was heard of in *The Hitch-Hiker's Guide To The Galaxy*). His hunt to the death story, 'The Seventh Victim' (1953), filmed as *La Decima Vittima* (1965) and then novelised as *The Tenth Victim* (1966) was an anticipation of Bachman/King's *The Running Man* (1982) and John Woo's *Hard Target* (1993), the belated prequel and sequel, *Victim Prime* (1987) and *Hunter/ Victim* (1988) being disappointments.

Sheckley started publishing short stories in the 1950s, when sf was making a conscious effort to become more literary – see the stories and novels from this period of Theodore Sturgeon, Alfred Bester, Philip K Dick and especially Kurt Vonnegut – and Sheckley's writing combines style with philosophical flourishes, and metaphysical slapstick. Like Bester, he was never quite as prolific as we might wish, having a handful of sf novels and ten crime or spy thrillers to his name. The eclipse of his reputation is such that when one of his few media tie-ins appeared – he has written *Buck Rogers In The Twenty-Fifth Century* and *Aliens* fiction – one reviewer saw him as a writer with promise. Even the release of *Freejack* (1992), which bought the concept but abandoned the apparatus of *Immortality, Inc.* (1958), did not lift the obscurity.

The premise of many of Sheckley's novels is that alien environments are alienating, and what you don't understand, appears alien. His protagonists are tossed out of their comfortable routines into strange locations, strange planets, even strange universes. The novels digress, philosophise, break down and putter to a twist ending – or a series of twist endings, which can undercut what has gone before entirely, and certainly doesn't return to the comfortable existence of the hero's earlier life, although he may think he's comfortable.

Options is perhaps the most extreme example, built on a slender premise: Tom Mishkin's spaceship breaks down and he lands on a planet in search of a spare part. Since there was some worry about what would happen if a spaceship crashed on the parts centre, the spare parts are located at various points on this hostile planet. Fortunately he is given a robot to help him navigate the dangers of Darius IV, but unfortunately this is the planet Harmony. Mishkin experiences a series of attacks, hallucinations and setbacks in his quest, as well as interventions by philosophers Immanuel Kant and David Hume.

Clearly the character has to be prevented from getting the spare part in order to prolong the novel, but Sheckley puts in difficulties no one could have foreseen – at one point a motorcycle courier appears to have the part but unfortunately he drives over a landmine. Before long it gets too much for Sheckley, and he ponders whether it wouldn't be better to write a cookbook (see Tom Robbins's *Still Life With Woodpecker* and Kurt Vonnegut's *Breakfast Of Champions* for other examples of authors in peril). Sheckley even abandons Tom Mishkin in favour of a new protagonist, a better hero.

Sheckley, the man with a thousand disguises, pushes the genre of sf about as far as it can go without breaking it, which perhaps explains why his output is so slim. It can never quite be the same again.

Princes Quay

Shopping centre, early 1990s, Hull, UK.

No one says dancing about architecture is like writing about music; does that mean it's easier to write about dance hall designs? But architecture is so central to early postmodernism that it's easy to lose sight of it; where to begin? Whereas architecture once concealed its design – the buttresses and arches of medieval cathedrals being structural as well as aesthetic choices, the mock gothic of Tower Bridge hiding a steel structure – late twentieth-century buildings wore their ducts, lifts and supports on their sleeves. The Millennium Dome in the middle of reclaimed, gas poisoned, land north of Greenwich, UK, was the most expensive big top in history, built and designed with no concept of what was to go in it. Function would follow form as soon as they worked out what it was for.

The Jubilee underground line extension, built to get tourists to the Dome, offers many fine new stations, that are worth visiting, and cuts through the Docklands redevelopment. The Docklands Light Railway gives fine views of the disparate architecture in the Isle of Dogs area – whereas you need to walk up the canal in Limehouse to see the gasworks mentioned in Eliot's *The Waste Land*. The trains themselves, which have no drivers, almost seem to be a metaphor for the area and the age: this is capitalism with the workers removed.

Meanwhile the industrial sites of the country are being redeveloped, sometimes sensitively (the Tate Modern gallery in an old power station), sometimes not. In the early 1990s a glass and metal shopping centre landed like an alien spaceship on the disused Princes Dock in Hull city-centre, completely out of keeping with the area's architecture, which admittedly was a mix of

Victorian civic pride and post-war concrete rebuild. The location was renamed Princes Quay – docks are smelly, dirty places where people work, whereas quays are pleasant places, where you could take a favourite aunt on a Sunday afternoon. The interior has the monumental mall architecture that seems to be quoting the future metropolis built in the film *Things To Come* (1936).

One of the writers of this book showed the other around the top floor, a darker space, devoted to small stores which weren't part of chains. The design meant that one area looked like part of Manhattan, another part like the Hollywood Hills, a third like New Orleans, a fourth like a western. US geography was condensed into metres. One of the authors explained to the other, 'They built this from old film sets.' The other responded, 'What, *real* film sets?'

The Stinky Cheese Man and Other Fairly Stupid Tales

1992. Written by Jon Scieszka. Illustrated by Lane Smith. New York: Penguin.

Want to expose your children to postmodernism before they're irretrievably damaged by reality? You could do far worse than give them or read to them from Scieszka and Smith's picture books. Of course, it helps if they know the fairy tales that are being subverted here: *Cinderella, Jack And The Beanstalk* and *The Ugly Duckling* for a start.

The latter can stand as one example of the way Scieszka subverts the form. Two ducks have a number of ducklings, one of which is really ugly. Of course this duckling is held up to ridicule as in the Hans Christian Andersen original, but here there is no reassuring moral conclusion where the duckling turns out to be a beautiful swan. No, the duckling grows up to be a really ugly duck. The end.

Scieszka and Lane subvert the nature of the picture book – on the back cover the little red hen objects to the ugly barcode and wants to know what an ISBN is, before springing onto the front endpaper to prevent Jack from starting the book. Jack is confused by the interruption, and he forgets the contents page, which crashes into the middle of one of the stories. The stories themselves either subvert familiar tales, marry two or more quite separate tales, end up as circular, prove too difficult to tell or finish too early, leaving a blank page. This is *Tristram Shandy* for the primary school reader.

The two have produced several other picture books, of which the closest in tone is *Squids Will Be Squids: Fresh Morals Beastly Fables* (1998), a collection of fables such as 'Elephant & Mosquito' and 'Duckbilled Platypus Vs. BeefSnakStik[®]', complete with morals like: 'Just because you have a lot of stuff, don't think you're special' or 'Elephants never forget, except sometimes'. In *The True Story Of The 3 Little Pigs By A Wolf* (1989) the familiar story of the three little pigs, with their house of straw, wood and bricks, is retold from the point of view of the Big Bad Wolf who claims he was framed and had only gone around to borrow a cup of sugar. On the one hand the story is upturned and the pigs revealed to be partially responsible for their own fate rather than helpless victims, but on the other you become uncomfortably aware that the wolf's interests are being served and perhaps the story he is telling isn't the true story after all. Scieszka and Smith have also written science fiction novels for pre-teens, featuring The Time Warp Trio who travel backwards or forwards in time thanks to their magician uncle's book.

There are many other children's books which subvert the form – retelling of fairy-tales from modern perspectives, where the author becomes a character, or pictures are at cross purposes with the text. One of the classics, Heinrich Hoffman's *Shockheaded Peter* (1844), is itself a parody of children's stories which expect children to be angels rather than little horrors. Aidan Chambers's *Breaktime* (1978), aimed at teenagers or young adults, has an unreliable narrator who may have invented the entire story. The text breaks up and plays typographical tricks, while a sex scene splits the page into two columns: an interweaved description of the act and a character's thoughts and an extract from a sex manual for teenagers by Dr Spock (the child-rearing guru, not the Vulcan. Obviously). Even kids can do intertextuality.

The Unusual Life of Tristan Smith

1994. Written by Peter Carey. London: Faber & Faber.

This novel is the life story of Tristan Smith, narrated by himself, who was born deformed (an ugly, lipless face, distorted legs) in the imaginary archipelago of Efica. It comes complete with footnotes, some supplied by Smith himself, some by the editor. Smith has grown up in a circus-style theatre and wants to be an actor, much to the annoyance of his Voorstand-born actor-manager mother who doesn't want him to suffer. But Smith and his mother find themselves caught up in two dramas: the battle within families and local politics.

On the one hand, this novel seems to be set within the real world, but it is clearly an imaginary corner of it. Efica is somewhere in the southern hemisphere (possibly the South Pacific), whereas Voorstand, a former Dutch settlement straddles the Arctic Circle. The two locations don't appear to be that far apart, either. This strange perspective is heightened by Tristan's narration of his own life in the third person – as well as some times in the first – and his account of events which he cannot have knowledge of.

Carey, perhaps Australia's foremost living novelist, has long mined the fabulous interzone between realism and the fantastic, most clearly in the various stories that make up the *Fat Man In History* (1974) – the most haunting is a story called 'Peeling', a psychosexual striptease in which a lover, Russian doll-like, is revealed to be one of many layers of identity. His early novels also hover on edges: *Bliss* (1981) may or may not be an account by a dead man and *Illywacker* (1985) is a tale told by a liar. Even the relatively straightforward *Oscar And Lucinda* (1988), an account of an attempt to erect a glass church somewhere in Australia, is made unsettling by the characters being named after characters in Günter Grass's *The Tin Drum* (1959).

In an act of cultural imperialism we might label Australia as the postmodern territory *par excellence*, with its cosmopolitan, international mix in western style cities and its distinctly pre-modern aboriginal culture. There is a sense that the landscape is somehow not real – in a number of recent films Australians go on the road to find themselves, only to return to cities for an authentic existence. Meanwhile those same cities – especially Sydney – become the unreal cities of *Dark City* (1997), *The Matrix* (1999) and the *Moulin Rouge*. And *The Songlines* of Bruce Chatwin's (entirely inaccurate?) 1987 novel offer us a utopian vision of a landscape mapped by an oral tradition.

As a former colony (yet not yet tough enough to become a republic), as an outpost of Hollywood (Warner Brothers and Fox both have studios there) and as a key player in the Pacific Rim, Australia represents the empire writing back, challenging 'down under' stereotypes as it exports culture (and wine) up over to the old world – it is also a country where the pianos never go out of tune. We are a long way from Australia being the perfect place to film the end of the world (although Ava Gardner's quote to this effect while filming *On The Beach* (1959) is almost certainly apocryphal) – and yet the country can be the centre of the apocalypse of the now, the askew, the next big thing, the ultra-modern, the postmodern.

Velvet Goldmine

1998. Directed and written by Todd Haynes. Starring: Jonathan Rhys Meyers (Brian Slade), Ewan McGregor (Curt Wylde), Christian Bale (Arthur).

It is the tenth anniversary of the faked death of glam rock star Brian Slade, and journalist Arthur is sent by his editor to find out what happened to him. He's able to find three people, who manage to tell Slade's story, one in a wheelchair, one drunk in a bar – yes, this is the narrative structure of *Citizen Kane* (1941), even down to the minor details, except that this time the journalist's story is almost important. Because, before he ran away to New York, Arthur was a glam rock fan, and knows more of the story than he realises. Slade is a Bowie-esque figure, sexually ambiguous, identifying with a persona, starting a sexual revolution that perhaps its fans aren't quite ready for, and given to Wildean epigrams. Indeed, the film starts with the depositing by aliens of Oscar, the first pop idol, onto the doorstep of the Wilde family, and the film quotes from *The Portrait Of Dorian Grey* (1891).

The film veers between a nostalgic recreation of the 1970s, complete with Super8 and 16mm footage, and a daring attempt at faux realism: we only know that Arthur is in New York in 1984 because the caption tells us so – it's all too clearly Croydon, and the cars drive on the left side of the road. A sign says East Broadway, but surely no one is fooled. It's a deliberately false note in a film full of camp, of irony and of performance – with three leads who can easily be mistaken for each other in wigs and make up.

Haynes's first feature film, *Poison* (1990), weaves a similar web of incongruous materials and elements of camp: a narrative of a boy who flew, a gothic horror of a scientist who isolates a chemical which causes sexual desirability and a homage to Jean Genet's prison writings. These elements allow Haynes to explore being an outsider and being homosexual in subtle and obvious ways, and was a central film in the early 1990s New Queer Cinema movement, characterised as homo pomo.

Other films of this loose group – as much a marketing device as anything – include *Swoon* (1991), Tom Kalin's apparently realist depiction of the Leopold and Leob case, and Gregg Araki's *The Living End* (1991), an existential HIV road movie. *Swoon* was in many ways a reaction against Hitchcock's *Rope* (1948), which was one of a series of Hitchcock films with killer gays. Kalin returned the story to its historical context, of Prohibition period Chicago, and was rather more graphic in depicting sexual favours in return for criminal acts (homosexuality, of course, then being a criminal act). On the

other hand, it's not so fetishistically accurate that it doesn't contain touchtone phones.

The Living End features a leather clad sociopath on the run from a killing and a sensitive Godard-loving film journalist who has just learned he is HIV positive. As they are going to die, they decide to go on the road, courtesy of a stolen credit card. They have nothing left to lose. These are not the politically correct, sensitive gay men who were beginning to show up as token characters – these are sociopaths and worse, but portrayed by openly gay directors rather than the homophobic depictions by straight directors which had been the norm for a century. The New Queer directors took back the stereotype. (HIV was central to the later career of Derek Jarman. One of New Queer Cinema's godfathers, his film *Blue* (1993), featured an entirely blue screen throughout.)

Gregg Araki was perhaps the most prolific of the group, having gone on to make a loose trilogy of slacker films *Totally F***ed Up* (1993), *The Doom Generation* (1995) and *Nowhere* (1996). These feature more of a queer, incongruous, overdesigned sensibility than dealing directly with gay characters, although love between men becomes increasingly central to the latter two, which both feature entirely unexpected endings. (No, believe us, you *won't* see it coming.)

While many of these films preached to the perverted or crowed to the converted, the new perception of there being narratives to be told about gay men other than coming out or dying of HIV enabled gay subjects to receive more mainstream treatment and gay characters to feature in romantic comedies from *The Opposite Of Sex* (1998) to *American Beauty* (1999). Whether we can forgive New Queer Cinema for this remains to be seen.

Videodrome

1982. Directed and written by David Cronenberg. Starring: James Woods (Max Renn), Debbie Harry (Nicki Brand).

Videodrome offers an early example of the postmodern feel that can be achieved by satirising television on film (see *The Truman Show* (1998) and *ED-TV* (1999) for alternate takes on reality television). Toronto cable TV executive Max Renn is seeking for the cutting edge of pornography when he stumbles across Videodrome, hardcore material being beamed out from Pittsburgh. On a chatshow he meets feminist Nicki Brand and Brian O'Blivion (who only appears on a television monitor) and this leads him towards the secret of Videodrome. Sexual desires get mirky as Max (inside Videodrome)

starts whipping Nicki (or rather her televisual image); at points he merges with his television screen.

It would be a shame to give the ending away, but suffice it to say that Max has a series of hallucinations inspired by Videodrome in real life, or perhaps he is still in Videodrome and hasn't returned to real life (we never see him remove the headset). The hyperreal has taken over the real, and the film's slogan, 'Long live the new flesh!' has become a rallying cry for postmodern critics obsessed with 'beating the meat' (which is not to imply that they are, er, meat beaters, although some are, but rather that they feel the body is obsolete).

After a period of literary adaptations (to the extent that *Dead Ringers* (1988), *Naked Lunch* (1991), *M Butterfly* (1993) and *Crash* (1996) are *literary*, dealing as they do with perverted desires, hybrids and crossing genders), Cronenberg virtually remade *Videodrome* in the shape of *eXistenZ* (1999), although by now the conceit of the computer game is available rather than just some kind of three-dimensional telly. Here again it is difficult to establish what base reality is, as the film begins midgame. The leading game designer, Allegra Geller (Jennifer Jason Leigh), is testing her new game eXistenZ with a focus group when she is attacked by a gun-wielding fanatic. She escapes with Ted Pikul (Jude Law) and holes up in a motel to recover and check the game is ok. For this Ted needs to participate, but – what are the odds? – her personal bodyguard Ted is the one person around without a game port (something to do with fear of penetration at the bottom of the spine). The film is fun enough, with a shuffling of reality, and the Dickian references (to Perky Pat from a story 'The Days Of Perky Pat' and a novel *The Three Stigmata Of Palmer Eldritch*) seem as playful as those to Baudrillard in *The Matrix*.

Cronenberg had also anticipated postmodern obsession in his Burroughsian use of virus, in part in *Rabid* (1976) and especially *Shivers* (1974), where the virus spreads sexual desire of all kinds. Being set in a new high rise, utopian community, also allows Cronenberg to anticipate Ballard's skyscraping version of *Lord Of The Flies* for adults (is that a desperate enough comparison for you?), *High-Rise*. There must have been something in the water (and no we don't mean the turd-like slug which climbs alarmingly through the plughole in *Shivers*). The film can even be read as having a happy ending – after all, the virus lives happily ever after.

Vurt

1993. Written by Jeff Noon. Littleborough: Ringpull.

Even in the megacorporate world a first time novelist can sometimes burst onto the scene from a new publisher with little or no advertising budget: Jeff Noon is one such person, and the novel was *Vurt*. Set in south central Manchester, in particular in Rushulme, Moss Side and West Didsbury, the main characters are the Stash Riders, who take hallucinogenic Vurt feathers to obtain an experience which is part way between a drug trip and a computer game – a consensual hallucination. After taking a feather called Curious Yellow within a feather called English Voodoo, Desdemona has disappeared, and in her place as an exchange, there is the feather growing Thing-From-Outer-Space. Her brother, Scribble, wants to rescue her, and must find the right feathers to do so. The novel found a market and news spread by word of mouth to such an extent that it won the 1994 Arthur C Clarke Award and a poll of reviewers in the British Science Fiction Association magazine *Vector*. A sequel, *Pollen* (1995) followed, but then Ringpull kicked the can and Noon moved to other publishers. Two more sf novels followed – an Alice in Wonderland pastiche, *Automated Alice* (1996) and *Nymphomation* (1998) – before Noon moved on: from Manchester, and aside from a story collection (*Pixel Juice* (1999), out of sf into concrete poetry (*Cobralingus* (2000)) and music culture (*Needle in the Groove* (2000)). In late 2002 he returned to sf with *Falling Out Of Cars* (2002).

Vurt's set up is essentially Scooby Doo as written by William S Burroughs, a gang with a van, taking drugs. But this overlays the Orpheus myth which is present in much cyberpunk – as well as *Moulin Rouge* – in which the bard goes into the Underworld to rescue his true love. Scribble's love for Desdemona (the name of a wronged tragic heroine in Shakespeare's *Othello*) is incestuous and perhaps sordid. The base reality, near-future Manchester, is perhaps more poetic than might be imagined, with a mythic sense lying behind the characters and striking images being sparked by the broken glass of abandoned bottles. The people are strangely different, being mostly hybrids: of robots, dogs, shadows (the telepathic) and so forth. (In the short story 'Ultra Kid And The Cat Girl', there is the suggestion that the mutants are the result of music recombining DNA sequences, but that's later.) The novel mixes the surreal – or to be more musical, remixes the surreal.

The novel spirals into itself, beginning with a boy putting a feather in his mouth, and ends with the boy removing it. The story itself could in fact just be a Vurt dream rather than a true story – as if that has any meaning when talking

about a work of fiction. It is made clear that Scribble is writing the story from some years later, and at various points it is retold, or restarted, with Scribble wanting to revise it for the better.

Noon has yet to recapture the surprise of his debut, although *Pollen* has its moments. This remixed cyberpunk has a strangely rural feel as the pollen count in Manchester rises, and new hybrids appear, mixing human and plants. This time the central protagonist is a shadowcop, telepathic but unable to use Vurt feathers and dedicated to stopping illegal flights. She attempts to stop this invasion of fauna, having to do battle with John Barleycorn, the spirit of grain, as well as numerous archetypes. *Automated Alice* yields to Noon's temptation to the pun, and makes much play of language (or *écriture*), as well as pointing the way to Alice (or is it Celia?) Hobart, the pioneer of Vurt. Even more hybrids line the mean streets. *Nymphomation* is an improvement, as Noon satirises the British National Lottery, and returns to the rescue quest in the form of the missing Miss Sayers, lost in the House Of Chances. The racial diversity of Manchester is acknowledged more subtly than in the previous books. He remains, however, a name to watch.

White Noise

1984. Written by Don DeLillo. New York: Viking.

Sometimes it feels that any post-war American novelist is a postmodernist, in part because their own character becomes as much part of their output as their novels: the public personae of writers as different as Norman Mailer, Tom Wolfe, Kurt Vonnegut, Ken Kesey, William Burroughs, Jack Kerouac are more distinct and well-known than their novels, and even notorious recluses such as Thomas Pynchon and JD Salinger are as famous for their failure to engage with the media as for their output (and we simply refuse to belittle and fillet Pynchon's novels to fit this book, not even to note that *Gravity's Rainbow* (1973) echoes Dick's *Time Out Of Joint* or prefigures cyberpunk). American novelists seem to have more consistently confronted the contemporary than British novelists – who in contrast seem more provincial. Of course we mustn't confuse the familiar with the provincial, or pretend the different is in itself exotic and therefore better, but these novelists have analysed the culture that has spread virus-like (to use Richard Dawkins's idea, the meme has spread) around the world.

White Noise is a comedy about the fear of death, centred on the experiences of Jack Gladney, an academic who has reinvented himself as the sun-

glasses-wearing JAK Gladney, chair of the department of Hitler Studies, Blacksmith College. Throughout the novel he is frightened of dying, and frightened of dying prior to his wife, who has started taking an experimental drug that will stop her being afraid of death. Meanwhile, his best friend, Murray, a visiting professor, is obsessed with the deaths of celebrities in car crashes. For Murray the car crash is a symbol of American optimism, the triumph of technology and ability. Each car crash is progress, an improvement on the last car crash.

The characters face a crisis when an accident allows the escape of a toxic chemical which causes *déjà vu* and will eventually kill anyone who has been exposed to it – including, he fears, Gladney. The disaster is mirrored later in the novel by various simulated disasters – and earlier in the novel one of his family was nearly killed in a plane crash – where the emergency services practise their techniques. They in fact prefer the simulation to the real thing: in fact they use the real event as a model for future simulations.

Meanwhile the Gladney family can take some consolation in watching television, and in an iconic postmodern moment: when Murray and Gladney visit the most photographed barn in America. This is a barn which looks pretty much like any other barn, but it has become a tourist attraction because it has been so photographed – so people come and photograph it. Murray argues that no one sees the barn only the aura of the tourist experience, which is in fact a religious, mystical experience.

Wicked: The Life And Times Of The Wicked Witch Of The West

1995. Written by Gregory Maguire. New York: ReganBooks.

Copyright notwithstanding, stories are the property of us all. When an author tells a story it escapes into the wild, beyond his or her control and mates with other stories. For whenever we read a story, we are aware of expectations, set up by other stories. This postmodern trend was probably started by Jean Rhys's *Wide Sargasso Sea* (1966), the story of *Jane Eyre*'s madwoman in the attic. A more recent example is Peter Carey's *Jack Maggs* (1997), not quite *Great Expectations* told from the point of view of Magwitch, the convict, but certainly centred on a convict who (allegedly) inspired Dickens. A related trend is the updating of classic stories, especially to a teen milieu; the best of these is still *Clueless* (1995). It was Josephine Saxton in the early 1970s who first rewrote fairy tales with a feminist agenda, but it is

Angela Carter who became best known for it, particularly 'The Company Of Wolves' in *The Bloody Chamber* (1979), later filmed by Neil Jordan. Philip Pullman's *I Was A Rat!* (1999) is a sequel to *Cinderella*, from the point of view of a rat page boy. But in a sense all fairy tales are rewrites of earlier models – writers are just being cheekier about it.

Maguire is not the only person to play with the Oz stories, Oz being an influence upon Derek Jarman and Salman Rushdie. Geoff Ryman wrote a multi-stranded novel called *'Was...'* (1992) which tells the story of Dorothy Gael, here L Frank Baum's inspiration for Dorothy in *The Wonderful Wizard Of Oz*. However, there is no escape for Dorothy from the farm of Aunt Em and Uncle Henry, nor would she wish to return there if she had: there is only grinding poverty and sexual abuse. Meanwhile, young Frances Gumm is being differently abused in vaudeville as a child star, before her big break as Judy Garland in *The Wizard Of Oz* (1939), a film watched on television by its aged model. And then there is actor Jonathan, Oz obsessed, researching the rôle of the scarecrow, who is dying of an AIDS-related condition. Ryman perhaps strips stories of fantasy and reality most bare in *253*. *Wicked* quickly dumps us into the world of Oz, first explored by L Frank Baum in *The Wonderful Wizard Of Oz* in 1900 and further mapped in a dozen sequels by Baum and many more by other writers. But this is not Dorothy's story – a naïve girl who could have little understanding of the politics of the world she has literally dropped in on – but the lifestory of Elphaba, the so-called Wicked Witch Of The West, whom Dorothy is doomed to kill. Elphaba is born ugly and green, and is more or less disowned by her father, although she is due to assume power in Munchkinland. She is educated at one of the finest schools in Oz, and becomes aware of the despotic rule of the usurping wizard, first in the oppression of the talking Animals, and then in the more general occupation of the land of Oz by the Wizard's armies. Elphaba becomes a freedom-fighter, but can never escape the thought that she is being set up, by Glinda, her teachers, her father, the wizard. Her name is made of the initials of Baum's name (El-Pha-Ba) but can also rearrange to Fabula, story. Maguire also produced *Confessions Of An Ugly Stepsister* (1999), a retelling of the Cinderella story from her stepsister's point of view, which among other things makes the point that stepmothers aren't intrinsically evil, nor is ugliness proof of evil.

7. Against Postmodernism

Although postmodernism seemed to sweep all before it in the 1980s and well into the 1990s, there have been a number of dissenting voices, and indeed a number of objections can be raised against it. This chapter will attempt – without getting buried in the minutiae of Immanuel Kant – to raise some of those objections. Perhaps it is curious that, despite these objections, and especially the sense that postmodernism was a fad or a band wagon, it has survived remarkably well as an approach through the nineties into the twenty-first century. Every time someone could declare it dead, another manifestation sprang up elsewhere – in law, in the social sciences, in embroidery, and so forth.

Post? What Do You Mean, Post?

The commonsense response is to assume that we are the moderns – that *now* is the modern era. And how can you be after now? Isn't that the future? And, just assuming for a moment that this is something that makes sense, where do we go next? What comes after the postmodern? The post-postmodern? And after that? The I-Can't-Believe-It's-So-Postmodern?

Hopefully by now we've clarified this, that postmodernism and postmodernity are after modernism and after modernity, which can be pinned down as specific periods, c.1890-c.1930 and the eighteenth century respectively. No one has worried about what might come after Post-Impressionism, or, since the Pre-Raphaelites happened after Raphaelites what would come... before... next... whatever. Something else will come along, and we will find a word for it.

At the same time, it perhaps still isn't clear that, aesthetically speaking, you can separate modernism and postmodernism. Joe Dante's films may be marked by a plundering of all kinds of popular cultural sources, but then so is James Joyce's *Ulysses*, a high modernist novel. It surely ought to be clear whether postmodernism is against modernism or a continuation of modernism, and to have one term to refer to both is not helpful. Meanwhile surely the make-it-new tenets of modernism can be characterised by avant garde art and art movements, but equally the everything's-been-said nature of postmodernism offers another avant garde.

It Ain't Over 'Til The Fat Lady Sings

Postmodernists such as Lyotard have argued that the project of modernity ran aground in the horrors of industrialised warfare, whether it was in the trenches or the concentration camps, and that the end result of rationality is inevitably going to lead to genocide. On the other hand, Jürgen Habermas has argued that modernity is, to date, an incomplete project. Christianity had over a millennium to root itself in Europe before the Renaissance and Humanism attempted to re-establish humanity as the measure of all things; but Christianity didn't stop in the sixteenth century, and still seems to flourish. Similarly, the modern as the ideology of the Enlightenment has only had a couple of centuries to get going, and may yet get it right.

The scientific advancements of the last two centuries have led to millions of lives being saved, and an improvement in the standards of living for most people. It is better that we have penicillin than not. It is better that we strive to find a cure for cancer or HIV than to trust to crystals or horoscopes or God's Will. But these things take time. And flu killed more people in 1918 than had died in the First World War.

The Uses Of Enlightenment

To some extent we inevitably construct an idea of the Enlightenment – synthesising the ideas of François Voltaire, Denis Diderot, Gotthold Lessing and Immanuel Kant almost as if these writers are interchangeable. Whenever we construct a movement, we emphasise the similarities and elide the differences. And some of these writers are difficult to get to grips with. Kant is perhaps the most significant thinker here, with his distinction (although interdependent connection) of understanding, ethics and judgement. Later thinkers – such as Lyotard, to some extent Baudrillard – have taken his ideas and either collapsed them together or only taken the part they were interested in, such as the sublime.

Christopher Norris's *What's Wrong With Postmodernism* (1990) is full of phrases like 'Schiller's seminal misreading of Kant' (21) and 'For Kant, as Lyotard reads him...' (219). The misreading of Kant is not just a postmodern one, but apparently true of those in the Romantic tradition, such as Friedrich Schiller, and a whole raft of Kantians, post-Kantians and neo-Kantians. Nor is it just Kant who is misread or read in a particular way (implying there are other ways to read him), but also Karl Marx and Jacques Derrida.

Norris's reading of Derrida is an interesting one (implying there are other ways to read him), in which he sees Derrida as continuing Kant's project, pushing the logic beyond where Kant would have it. This is what Derrida does, though, rather than the cartoon sketch of him which sees his ideas as negative or destructive. Derrida's essays respect the writings they set out to critique, even respecting the contradictions he finds at the heart of them; these contradictions are embraced rather than taken as signs that the text should be rejected. Derrida believes in a form of authorial intention (a notion rejected by others) if only so that he can read *against* it. Derrida, then, does not reject Kantian thought, but embraces it, which goes against the definition of post-modernity as rejecting the Enlightenment. But then, for Norris, Derrida is different from postmodernists.

Fascist!

The politics of modernism are problematic. In facing the ruins of civilisation, too many of them saw the possibility of an intellectual or cultural élite rising above the problems brought on by the rise of the masses, and perhaps saw themselves as some kind of Nietzschean supermen. TS Eliot has been accused of anti-Semitism, WB Yeats moved to the right and Ezra Pound was imprisoned for his sympathies with fascism.

At the same time, there is the spectre of Martin Heidegger, a figure who perhaps did the most to break with modernity, who in *Being And Time* (1927) saw all of the world, including the people in it, as a means of helping the individual stave off angst about the fact that you could die at any point. Heidegger can be understood as the philosopher of Naziism, and his position of Rector of Freiborg University puts him as an authoritative figure at the start of the rise of Adolf Hitler. There has been much debate as to whether Heidegger only briefly embraced Naziism (it is too early to be a survival tactic) or whether it informs his entire output. Heidegger may have found in Naziism a politics which represents the culmination of his thinking, or (or indeed and) Heidegger's ideas provided intellectual validation for Naziism.

Then there is the case of the wartime record of the literary theorist, Paul de Man. De Man was a disciple of Derrida's, and argued that all writing was ironic, and that each text had a blindspot which would reveal its instability of meaning, symptomatic of the deferral of meaning discussed in the previous chapter. As de Man was the leading American deconstructionist, attacked by cultural commentators on the right, it was somewhat ironic that it emerged that de Man had a rather unfortunate war record in German-occupied Bel-

gium, and that he had written journalism sympathetic to Naziism. In perhaps the most uncomfortable moment, he had suggested that had all the Jews been transported to an island off the coast of Europe, than mainland European thought and aesthetics would be no different. De Man had misled the rest of the world about his and his family's rôle in occupied Belgium, to his own advantage. Cynically, we might say that his wartime writings were ironic (perhaps in the Swiftian tradition), or we might want to disregard his ideas.

It should be clear that much of postmodern thought either comes from or is accused of coming from a right-wing perspective. Habermas, who saw postmodernism as rejecting the avant garde, accused postmodernists (especially Lyotard) of being neoconservatives. This seems ironic since conservatives have hardly been more accepting of many postmodern (especially so-called nihilistic) ideas. But it is not just the spectre of Nazi collaboration that tars postmodernity, and indeed postmodernism, with a right-wing brush.

1968 And All That

In May 1968 the students in Paris went on strike, demanding better conditions in classrooms and more radical teaching, and this led to a showdown with police on May 10. The student strike then spread to other workers, ten million being on strike within two weeks. However, the government negotiated with the French Communist Party and some of the strikers, leading to a diplomatic end to the strike and avoiding the overthrow of President de Gaulle. The uprising was seen as a failure by the radical left, and left to a disenchantment with Marxism and Communism among leading cultural commentators.

Lyotard, Baudrillard and Derrida had all been writing prior to the May 1968 events, and in the case of the first two there is a clear move away from Marxist ideas in the following years. This, inevitably, is interpreted as a move to the right, and a retreat from the possibility of a revolutionary struggle. In Derrida's writings there was not so much a move away from Marxism, as a continued refusal to deal with Marx's ideas while he invoked Hegel, Heidegger, Freud, Levinas and others. This refusal came to an end after the fall of the Berlin Wall in 1991 and the collapse of the Soviet Bloc; it is the moment that Marxism might be thought to die that Derrida declares his interest in and neglect of it – in *Specters Of Marx* Derrida offers a deconstructive reading of *The Communist Manifesto*, *Hamlet* and Francis Fukayama's *The End Of Man*. Derrida's forty year examination of deconstruction could be read as an explo-

ration of a form of dialectical (that is Hegelian or Marxist) thinking, where he finds unreconcilable theses and antitheses.

It is clear that for many postmodern thinkers the horrors of the period between the mid-1920s and 1945 which included Fascism and Stalinism, as well as post-war events in Poland, Hungary, Czechoslovakia, left them with a distrust of political ideologies. The metanarratives of Naziism, Fascism and Stalinism were to be distrusted and avoided – and for many the horror that accompanied the practice of Stalinism was sufficient to discredit the ideas of Marxism.

The political readings of the post-1968 world, especially those by Baudrillard, avoiding the analysis of ongoing class struggle favoured by Marxist thinkers, were readings which ignored the true injustices of the world. The hamburger in Red Square or Trafalgar Square might demonstrate the collapse of national boundaries, but ignores the material conditions of exploitation of the workers who have made that hamburger. The hyperreality of Disneyland may conceal a wider oppression by the state, but it specifically moves away from the critique of ideology and false consciousness which dominates the class system.

Alex Callinicos, in *Against Postmodernism* (1989), takes Fredric Jameson to task for his analysis of the break in capitalism that occurs in the 1960s, and the shift in terminology from post-industrial to late capital or post-Fordism that thinkers such as Jameson adopt. According to Callinicos, this is a misreading of Mandel's ideas, which were mapping a post-war boom and bust that had reached its height in the mid-1960s. Callinicos also suggests that postmodernists have rather overplayed the breakdown of the nation state and the power of the multinational corporation.

Thatcherism And Reaganism

The late 1970s were marked by the emergence of two right-wing leaders who swept into power amid the collapse of the left: Margaret Thatcher in Britain and Ronald Reagan in the United States. Both set about radical agendas of social change; Thatcher privatised as many of the nationalised industries as she could, while extending legislation to cover the personal. In both cases the tax burden was decreased on the wealthy, in order to allow them to generate wealth. Reagan, meanwhile, seemed to confuse his film career with his autobiography, and seems increasingly hyperreal as time goes by. Thatcher gave way to John Major, and Reagan to George Bush, before the tide appeared to

turn back to the left. But the Labour Party had reinvented itself so as to lose any socialist, certainly any Marxist, taint, and Clinton seemed paralysed first by celebrity and endless speculation about sexual and business misconduct. When Vice President Al Gore came up against George W Bush there seemed barely an ideological distinction between them; meanwhile some of Blair's ministers made the previous régime appear open minded and generous in retrospect.

Political ideology has shifted from a sense of collective responsibility where radical change mind be brought about by a consensus to the triumph of the individual, unwilling to pay taxes for anything he or she doesn't directly benefit from. There can be no consensus for change, because there can be no communication between individuals. Thus Lyotard's concept of the différend, the inability to resolve issues because you are taking part in a different language game from other people, comes of age. Just as Heidegger had provided a philosophy for Naziism, so postmodernism offered an ideology for Thatcherism, Reaganomics and the New Right. It can be seen as prescribing, rather than describing. Analysis has turned to justification.

In the 1960s and 1970s there were successive waves of civil rights protests, for blacks, for gays and lesbians and for women. So-called minorities rightly fought for equality and difference became first an aspect of consciousness raising and then a badge of honour by the 1990s. One tactic of fighting for equality was to remove the stigma of Otherness that might be perceived through marks of difference: hybrid identities could mix sexes, races, sexualities. Uncanny figures such as Boy George and Michael Jackson blurred boundaries. But if we are all queer now, then a straight male can represent your interests as well as a lesbian, and suddenly the minority of the white, middle-class, straight male becomes an acceptable position.

In the individual struggle for the rights of individuals, the collective struggle that divided along class lines between capitalistic exploiters and the working class exploited was lost. Multi hyphenated and hybrid identities meant that you had nothing precisely in common with anyone else, and why should you care about anyone else? Minorities of one do not make a struggle. Meanwhile John Major declared Britain a classless society – as if saying it made it so – and then under Tony Blair we were all now middle class. As the Conservative party imploded, the Labour Party moved to the right and phone polls for evicting *Big Brother* contestants or choosing between *Pop Rivals* outnumbered votes in many elections.

If nothing is real, why vote? If ideology no longer matters, then why vote for a political party?

Single issue protests seem possible now, whether against petrol taxes, against bombing Iraq, for animal rights or for the countryside way of life, but these perhaps would only make cosmetic changes to society. These often seem like fashions rather than deeply held beliefs. But perhaps there is hope through postmodernism, that the perceived dissolution of national boundaries could pave the way for international justice of one kind or another. But that would demand a new, shared metanarrative, and mark the end of postmodernism and postmodernity.

Post Script: After The End

Since that previous paragraph was drafted the campaign against bombing Iraq was overtaken by the US and UK invasion to enact régime change. Saddam Hussein (once our ally against Iran) is finally deposed as we write, although they've yet to find much evidence of his weapons of mass destruction.

Did this Gulf War take place? A president who never seems to be the one running things sent the world's biggest army against a dictator who appeared to have endless doubles. The US used (then didn't use) a tactic of 'Shock And Awe', only to have its inventor declare that it wasn't Shock And Awe – although claiming it was turns out to be an example of Shock And Awe... The Iraqi régime's spin doctor denied that US forces held the airport a mile or so away. CNN and Fox Network fetishised the new technology, and journalists seemed to be the only casualties at first. British defence minister Geoff Hoon said that Iraqi mothers would thank him for his use of cluster bombs one day. The Iraqis claimed that they would ambush US troops with weapons they had previously claimed not to have, except that they didn't have them. Again it was a war of simulation and appearances.

But to aestheticise this event is obscene: people have died, and will die for years to come. Meanwhile Francis Fukuyama, once cosignatory with Donald Rumsfeld and others of a letter to President Clinton demanding the removal of Saddam Hussein, recently suggested that history isn't quite over yet. Perhaps the repoliticisation of thousands, and the politicisation of a new generation, means that there is much history left.

References

Books

Introduction

Plato, *The Republic*, edited by Desmond Lee. (Harmondsworth, Middlesex: Penguin, 1987).

Jacques Derrida, 'Plato's Pharmacy', in *Disseminations*, edited by Barbara Johnson (Chicago: University of Chicago Press, 1981), pp. 79-158.

Edward Hussey, *The Presocratics* (London: Duckworth, 1972).

Charles Jencks, *The Language Of Post-Modern Architecture* (London: Academy Editions, 1977).

Charles Jencks, *Postmodernism* (London: Academy Editions, 1987).

Robert Venturi, *Complexity And Contradiction In Architecture* (New York: Museum of Modern Art, 1972).

David Watkin, *A History Of Western Architecture*, third edition (London: Laurence King, 2000).

Chapter One

Jean-François Lyotard, *The Postmodern Condition: A Report On Knowledge*, translated by Geoff Bennington and Brian Massumi and introduced by Fredric Jameson (Manchester: Manchester University Press, 1984).

Jean-François Lyotard, *The Postmodern Explained To Children: Correspondence 1982-1985*. (London: Turnaround, 1992).

Simon Malpas, *Jean-François Lyotard* (London and New York: Routledge, 2003).

Chapter Two

Fredric Jameson, *Postmodernism Or, The Cultural Logic Of Late Capitalism* (London and New York: Verso, 1991).

Chapter Three

Fake America and the Simulacra: Jean Baudrillard, *Simulations*, translated by Paul Patton, Paul Foss and Philip Beitchman (New York: Semiotext(e), 1983).

Umberto Eco, *Travels In Hyperreality: Faith In Fakes: Essays*, translated by William Weaver (London: Picador, 1987).

Schizophrenia: Jean Baudrillard, *The Ecstasy Of Communication*, translated by Bernard and Caroline Schutze (New York: Semiotext(e), 1988).

The Gulf War: Jean Baudrillard, *The Gulf War Did Not Take Place* (Sydney: Power, 1995).

Chapter Four

Meaghan Morris, *The Pirate's Fiance: Feminism, Reading, Postmodernism* (London and New York: Verso, 1988).

Mary Wollstonecraft, *A Vindication Of The Rights Of Woman / A Vindication Of The Rights Of Man* (Oxford: Oxford World's Classics, 1994).

Camille Paglia, *Sex, Arts And American Culture: Essays* (London: Penguin, 1993).

Hélène Cixous, 'Sorties', in *Modern Criticism And Theory: A Reader*, edited by David Lodge (London: Longman, 1988), pp. 287-293.

Julia Kristeva, *The Kristeva Reader* (Oxford and Cambridge, MA: Blackwell, 1986).

Julia Kristeva, *Powers Of Horror: An Essay On Abjection* (New York: Columbia University Press, 1982).

Michel Foucault, *The History Of Sexuality Volume I: An Introduction*, translated by Robert Hurley (Harmondsworth, Middlesex: Penguin, 1990).

Susan Sontag, 'Notes On Camp', *Partisan Review* 31 (1964), pp. 515-530.

Chapter Five

JG Ballard, 'Which Way To Inner Space?' *New Worlds* 40 (1962), pp. 2-3, 116-8.

Colin Greenland, *The Entropy Exhibition: Michael Moorcock And The British 'New Wave' In Science Fiction* (London: Routledge and Kegan Paul, 1983).

Colin Greenland, 'Jeremiah Cornelius And The Camelot Baseball Embargo', in *Mexicon IV Programme Book* (Harrogate: Mexicon IV, 1991): 9-13.

Fred Pfeil, *Another Tale To Tell: Politics And Narrative In Postmodern Culture* (London and New York: Verso, 1990).

Andrew M Butler, *Cyberpunk* (Harpenden: Pocket Essentials, 2000).

Cheap Truth online: http://dub.home.texas.net/sterling/cheap.html

Bruce Sterling, 'Slipstream', *Science Fiction Eye* 5 (1989).

Istvan Csicsery-Ronay Jr, 'Cyberpunk And Neuromanticism', in *Storming The Reality Studio: A Casebook Of Cyberpunk And Postmodern Science Fiction*, edited by Larry McCaffery (Durham and London: Duke University Press, 1991), pp. 182-193.

Joan Gordon, 'Yin And Yang Duke It Out', in *Storming the Reality Studio*, pp. 196-202.

Veronica Hollinger, 'Cybernetic Deconstructions: Cyberpunk And Postmodernism', in *Storming the Reality Studio*, pp. 203-218.

Brian McHale, *Postmodernist Fiction* (London and New York: Methuen, 1987).

Brian McHale, *Constructing Postmodernism* (London and New York: Routledge, 1992).

Donna Haraway, 'A Manifesto For Cyborgs – Science, Technology, And Socialist Feminism In The 1980s', *Socialist Review* 80 (1985), pp. 65-107.

Damien Broderick, *Reading By Starlight: Postmodern Science Fiction* (London and New York: Routledge, 1995).

Jenny Wolmark, *Aliens And Others: Science Fiction, Feminism And Postmodernism* (Hemel Hempstead: Harvester Wheatsheaf, 1994).

Chapter Six

This section does not repeat bibliographic details given in the chapter

John Ashbrook, *Terry Gilliam* (Harpenden: Pocket Essentials, 2000).

Mary Schmich, 'Vonnegut? Schmich? Who Can Tell In Cyberspace' (August 2 1997) http://www.hotink.com/schmich.html.

Scott McCloud, *Understanding Comics* (London: HarperCollins, 1993).

Greg McCue and Clive Bloom, *Dark Knights: The New Comics in Context* (London: Pluto, 1993).

John Newsinger, *The Dredd Phenomenon: Comics and Contemporary Society* (Bristol: Libertarian Education, 1999).

Jean Baudrillard, 'Simulacra And Science Fiction', *Science Fiction Studies* 18 (1991), pp. 309-313.

Jean Baudrillard, 'Ballard's *Crash*', *Science Fiction Studies* 18 (1991), pp. 313-320.

Roger Luckhurst, *'The Angle Between Two Walls': The Fiction Of J G Ballard* (Liverpool: Liverpool University Press, 1997).

Scott Durham, 'The Technology Of Death And Its Limits: The Problem Of The Simulation Model', in *Rethinking Technologies*, edited by Verena Andermatt Conley (Minneapolis: University of Minnesota Press, 1993), pp. 156-170.

Rob Latham, *Consuming Youth: Vampires, Cyborgs, And The Culture Of Consumption* (Chicago and London: University of Chicago Press, 2002).

Karine Constable, *Plane Dealing: The Art Of Greg Letham* (New York: Hocus Press, 1995).

Peter Fitting, '*Ubik*: The Deconstruction Of Bourgeois SF', *Science Fiction Studies* 2 (1975), pp. 47-56.

Andrew M Butler, *Philip K Dick* (Harpenden: Pocket Essentials, 2000).

Alex C Irvine, Review of Elaine Sauter, *What If Our World Were Their Heaven?* and Andrew M Butler, *Philip K Dick*, *Science Fiction Studies* 28 (2001).

Kim Stanley Robinson, *The Novels Of Philip K Dick* (Ann Arbor: UMI Research Press, 1984).

Michael Nyman, 'Against Intellectual Complexity In Music', *October* 13 (1980), pp. 81-89.

William S. Burroughs, *A William Burroughs Reader* (London: Picador, 1982).

Victor Bockris, *From The Bunker: With William Burroughs* (London: Vermillion, 1982).

Ted Morgan, *Literary Outlaw: The Life And Times Of William S Burroughs* (London: Pimlico, 1991).

Christine Vachon, *Shooting To Kill* (London: Bloomsbury, 1998).

B Ruby Rich, 'New Queer Cinema', *Sight & Sound*, 2 (1992), pp. 31-34.

Justin Wyatt, *Poison* (Trowbridge: Flicks Books, 1998).

Chris Rodley, *Cronenberg on Cronenberg* (London and Boston: Faber & Faber, 1997).

John Costello, *David Cronenberg* (Harpenden: Pocket Essentials, 2000).

Michael Grant, ed., *The Modern Fantastic: The Films of David Cronenberg* (Trowbridge: Flicks, 2000).

Chapter Seven

Christopher Norris, *What's Wrong With Postmodernism: Critical Theory And The Ends Of Philosophy* (Hemel Hempstead: Harvester Wheatsheaf, 1990).

Alex Callinicos, *Against Postmodernism: A Marxist Critique* (Cambridge: Polity, 1989).

Further Reading

Richard Appignanesi, Chris Garratt, Ziauddin Sardar and Patrick Curry, *Postmodernism For Beginners* (Trumpington, Cambridge: Icon Books, 1995).

Jean Baudrillard, *Selected Writings* (Cambridge: Polity Press, 1988).

Steven Connor, *Postmodernist Culture: An Introduction To Theories Of The Contemporary* (Oxford: Blackwell, 1997).

Thomas Docherty, *Postmodernism: A Reader* (London: Harvester Wheatsheaf, 1993).

John Docker, *Postmodernism And Popular Culture: A Cultural History* (Cambridge: Cambridge University Press, 1994).

Mike Featherstone, *Consumer Culture And Postmodernism*. London: Sage, 1991.

Hal Foster, ed., *Postmodern Culture* (London: Bay Press, 1983).

Ihab Hassan, 'POSTmodernISM', *New Literary History*, 3 (1971), pp. 5-30.

Dick Hebdige, 'A Report On The Western Front: Postmodernism And The 'Politics' Of Style', *Block* (1986/1987), pp. 4-26.

Chris Horrocks and Zoran Jevtic, *Baudrillard for Beginners* (Trumpington, Cambridge: Icon Books, 1996).

Linda Hutcheon, *A Poetics of Postmodernism: History, Theory, Fiction* (London: Routledge, 1988).

Arthur Kroker and David Cook, *The Postmodern Scene: Excremental Culture and Hyper-Aesthetics* (London: Macmillan, 1988).

Annette Kuhn, ed., *Alien Zone: Cultural Theory and Contemporary Science Fiction Cinema*, (New York and London: Verso, 1990).

Jean-Francois Lyotard, *The Lyotard Reader* (Oxford and Cambridge, MA: Blackwell, 1989).

Neil Nehring, *Popular Music, Gender and Postmodernism* (London: Sage, 1997).

Paul O'Brien, 'Postmodernism and Democracy', *Eari*, blue square issue (1993), pp. 32-39.

Pamela Robertson, *Guilty Pleasures: Feminist Camp from Mae West to Madonna* (London: I.B. Tauris, 1996).

Rudy Rucker, Peter Lamborn Wilson and Robert Anton Wilson, eds., *Semiotext(e): SF* (New York: Semiotext(e), 1989).

John Storrey, *Cultural Theory and Popular Culture* (Hemel Hempstead: Harvester Wheatsheaf, 1993).

Websites

Postmodern Culture http://www.iath.virginia.edu/pmc/contents.all.html - Electronic journal, founded in 1990, which deals with contemporary cultures and cultural phenomena.

Art and Culture http://www.artandculture.com/cgi-bin/WebObjects/ACLive.woa/wa/movement?id=131 p Lists some artists and links to relevant articles on their work.

Jacques Derrida http://www.hydra.umn.edu/derrida/ - A couple of years out of date but a good starting point on the theorist of deconstruction.

Fredric Jameson http://www.duke.edu/literature/Jameson.html - Jameson's faculty website - put a face to the name!
http://www.marxists.org/reference/subject/philosophy/works/us/jameson.htm - Two excerpts from chapter one of *Postmodernism*

Jean-François Lyotard http://www.marxists.org/reference/subject/philosophy/works/fr/lyotard.htm - Five chapters from *The Postmodern Condition*.

Jean Baudrillard http://www.uta.edu/english/apt/collab/baudweb.html - A starting point for Baudrillard, with plenty of links.

Hélène Cixous http://sun3.lib.uci.edu/~scctr/Wellek/cixous/ - Secondary bibliography on the French Feminist.

Julia Kristeva http://www.cddc.vt.edu/feminism/Kristeva.html - Summary of her ideas and a bibliography and interview.

Susan Sontag http://pages.zoom.co.uk/leveridge/sontag.html - A version of 'Notes On Camp'.

Donna Haraway http://www.stanford.edu/dept/HPS/Haraway/Cyborg-Manifesto.html - Ssshh! Don't tell anyone but it's the full text of the Manifesto.
http://www.popcultures.com/theorists/haraway.html - Resources on Haraway.

Updates http://homepages.enterprise.net/ambutler/pe - Updates to this volume and others by Andrew M Butler.

The Essential Library: History Best-Sellers

Build up your library with new titles published every month

Conspiracy Theories by Robin Ramsay, £3.99

Do you think *The X-Files* is fiction? That Elvis is dead? That the US actually went to the moon? And don't know that the ruling elite did a deal with the extra-terrestrials after the Roswell crash in 1947... At one time, you could blame the world's troubles on the Masons or the Illuminati, or the Jews, or One Worlders, or the Great Communist Conspiracy. Now we also have the alien-US elite conspiracy, or the alien shape-shifting reptile conspiracy to worry about - and there are books to prove it as well! This book tries to sort out the handful of wheat from the choking clouds of intellectual chaff. For among the nonsensical Conspiracy Theory rubbish currently proliferating on the Internet, there are important nuggets of real research about real conspiracies waiting to be mined.

The Rise Of New Labour by Robin Ramsay, £3.99

The rise of New Labour? How did that happen? As everybody knows, Labour messed up the economy in the 1970s, went too far to the left, became 'unelectable' and let Mrs Thatcher in. After three General Election defeats Labour modernised, abandoned the left and had successive landslide victories in 1997 and 2001.

That's the story they print in newspapers. The only problem is…the real story of the rise of New Labour is more complex, and it involves the British and American intelligence services, the Israelis and elite management groups like the Bilderbergers.

Robin Ramsay untangles the myths and shows how it really happened that Gordon Brown sank gratefully into the arms of the bankers, Labour took on board the agenda of the City of London, and that nice Mr Blair embraced his role as the last dribble of Thatcherism down the leg of British politics.

UFOs by Neil Nixon, £3.99

UFOs and Aliens have been reported throughout recorded time. Reports of UFO incidents vary from lights in the sky to abductions. The details are frequently terrifying, always baffling and occasionally hilarious. This book includes the best known cases, the most incredible stories and the answers that explain them. There are astounding and cautionary tales which suggest that the answers we seek may be found in the least likely places.

The Essential Library: Currently Available

Film Directors:

Woody Allen (2nd)	Tim Burton	Ang Lee
Jane Campion*	John Carpenter	Joel & Ethan Coen (2nd)
Jackie Chan	Steven Soderbergh	Clint Eastwood
David Cronenberg	Terry Gilliam*	Michael Mann
Alfred Hitchcock (2nd)	Krzysztof Kieslowski*	Roman Polanski
Stanley Kubrick (2nd)	Sergio Leone	Oliver Stone
David Lynch (2nd)	Brian De Palma*	George Lucas
Sam Peckinpah*	Ridley Scott (2nd)	James Cameron
Orson Welles (2nd)	Billy Wilder	Roger Corman
Steven Spielberg	Mike Hodges	Spike Lee
Hal Hartley		

Film Genres:

Blaxploitation Films	Bollywood	French New Wave
Horror Films	Spaghetti Westerns	Vietnam War Movies
Slasher Movies	Film Noir	Hammer Films
Vampire Films*	Heroic Bloodshed*	Carry On Films
German Expressionist Films		

Film Subjects:

Laurel & Hardy	Marx Brothers	Film Music
Steve McQueen*	Marilyn Monroe	The Oscars® (2nd)
Filming On A Microbudget	Bruce Lee	Writing A Screenplay
Film Studies		

Music:

The Madchester Scene	Beastie Boys	Jethro Tull
How To Succeed In The Music Business		The Beatles

Literature:

Cyberpunk	Philip K Dick	The Beat Generation
Agatha Christie	Sherlock Holmes	Noir Fiction
Terry Pratchett	Hitchhiker's Guide (2nd)	Alan Moore
William Shakespeare	Creative Writing	Tintin
Georges Simenon	Robert Crumb	

Ideas:

Conspiracy Theories	Nietzsche	UFOs
Feminism	Freud & Psychoanalysis	Bisexuality

History:

Alchemy & Alchemists	The Crusades	The Black Death
Jack The Ripper	The Rise Of New Labour	Ancient Greece
American Civil War	American Indian Wars	Witchcraft
Globalisation	Who Shot JFK?	Videogaming
Classic Radio Comedy	Nuclear Paranoia	

Miscellaneous:

Stock Market Essentials	How To Succeed As A Sports Agent	Doctor Who

Available at bookstores or send a cheque (payable to 'Oldcastle Books') to: **Pocket Essentials (Dept PM), P O Box 394, Harpenden, Herts, AL5 1XJ, UK**. £3.99 each (£2.99 if marked with an *). For each book add 50p (UK)/£1 (elsewhere) postage & packing